MASTERPIECES
OF
THE FRICK COLLECTION

INTRODUCTION

HARRY D. M. GRIER

DIRECTOR

TEXT

EDGAR MUNHALL

CURATOR

THE FRICK COLLECTION · NEW YORK

DISTRIBUTED BY THE VIKING PRESS · NEW YORK

ACKNOWLEDGMENTS

Editorial Assistance: Bernice Davidson, Joseph Focarino

Design and Production: Manuel Gasser and Staff of DU Magazine

Poulenc quotation on p. 3 from John Gruen, *Close-Up,* The Viking Press, Inc., New York, 1968.

Photographs: The majority of black and white photographs of works of art by Francis Beaton; exterior view of The Frick Collection by Ezra Stoller (p. 3); view of Pittsburgh courtesy of the Carnegie Library of Pittsburgh (p. 4); room views by Lionel Freedman (pp. 10, 16, 19, 30, 37, 47, 61, 103, 118); color photographs by Joseph P. Corboy (pp. 15, 25, 28, 33, 39, 42, 51, 65, 75, 79, 83, 92, 97, 113, 117) and Geoffrey Clements (pp. 11, 17, 35, 55, 69, 89, 101, 109).

First published in 1970 by The Frick Collection, 1 East 70th Street, New York, New York 10021. Distributed by The Viking Press, Inc., 625 Madison Avenue, New York, New York 10022. Published simultaneously in Canada by The Frick Collection and distributed in Canada by The Macmillan Company of Canada Limited. Library of Congress catalog card number: 78-97172. Printed and bound by Conzett and Huber, Zurich, Switzerland. SBN 670-46194-6.

Table of Contents

This volume presents a selection of only some of the works of art in The Frick Collection, chosen from the different fields represented: painting, sculpture, the decorative arts, enamels, porcelains, drawings, carpets, and silver. Rather than arrange this material chronologically or by artistic categories, it was decided to reproduce key items in each gallery in the order they are normally seen by the visitor. In this way it is hoped that the particular, domestic atmosphere of The Frick Collection might be conveyed to the reader and that this book will thus constitute a souvenir of a visit to the Collection. For a complete description and discussion of every work of art in The Frick Collection, the reader is referred to the illustrated nine-volume Catalogue, now in publication.

Introduction

Francis Poulenc, when asked his opinion of a newly constructed contemporary museum, replied somewhat elusively, "...of museums, the one I love best in the whole world—and I have visited many—the one that gives me most joy, is the Frick Collection in New York.... Since I have a visual memory it is this museum which has often comforted me.... those beautiful paintings and the extraordinary building which houses them." So many persons from all walks of life—artists, connoisseurs, students, scholars, and tourists—have written extravagant praises of The Frick Collection that I feel only pride, not immodesty, in quoting this portion of Poulenc's remarks. This illustrated volume is published to refresh just such visual memories for some of the millions who have enjoyed visits to The Frick Collection, while for those who have not yet visited the Collection, or who may never make their way to Fifth Avenue and Seventieth Street in New York, these pages may provide something of a substitute. But despite the excellence of photography and of modern color reproduction, no book can replace the direct experience of viewing an art gallery, and this is especially true of The Frick Collection, where the various works of art are so harmoniously related within a residential setting that the whole ambiance becomes an important part of the visitor's experience.

This book is published in celebration of the fiftieth anniversary of the founding of The Frick Collection, which was incorporated in 1920. Coincidentally, it may be considered to mark the one hundredth anniversary of the beginning of Henry Clay Frick's collecting, for it was about 1870 that Mr. Frick started acquiring works of art; at least it was in

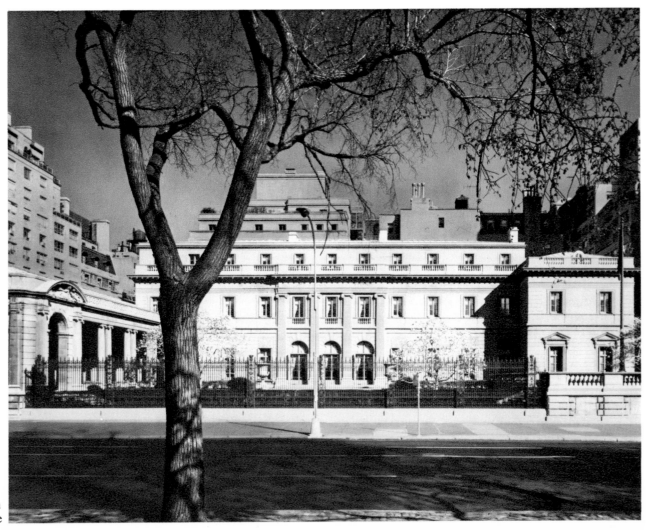

The Frick Collection
Fifth Avenue Façade

3

the following year that his interest in "pictures" was first recorded. At the age of twenty-one Mr. Frick, in partnership with two cousins, founded Frick and Company for the manufacture of coke. Coke, distilled from coal, is the fuel used in manufacturing steel, and the Frick company became a major supplier to the Pittsburgh steel industry. To expand the company he borrowed capital from the recently established Pittsburgh bank of Thomas Mellon and Sons, but his second request for a loan prompted Judge Mellon to investigate the firm and its prospects. The report submitted to him read: "Lands good, ovens well built; manager on job all day, keeps books evenings, may be a little too enthusiastic about pictures but not enough to hurt; knows his business down to the ground; advise making the loan." This report is the earliest documentary evidence of Mr. Frick's artistic interest, showing that in his early twenties he already had such an enthusiasm for art that it was noted by a credit investigator.

There is little in Mr. Frick's early life, his background, or his education to explain this interest in art. He was born in a rural community in southwestern Pennsylvania, the son of a farmer, John W. Frick, whose forebears had emigrated to the United States three generations earlier from Switzerland. He was raised on a farm and received very little formal schooling. At an early age he worked as a clerk for two of his uncles, and subsequently he became bookkeeper for his maternal grandfather, Abraham Overholt, a flour merchant and whiskey distiller, before going into business for himself.

Being an avid reader, it is possible that he acquired his enthusiasm for art through engravings and reproductions in books. What actual pictures he may have seen in the Pittsburgh area in 1870 remains somewhat of a question. Pittsburgh was not, however, without artists. In the time of Mr. Frick's youth there were a number of painters living there, several of whom had received training in Europe, and as early as 1828 the painter James Reid Lambdin opened a museum of natural history and gallery of painting which was the first museum organized west of the Alleghenies. It is, I think, safe to assume that Mr. Frick's initial interest was in the work of local painters such as David G. Blythe, George Hetzel, and B. F. Smith, whose pleasant view of Pittsburgh, illustrated here, shows the city in 1849, the year of Mr. Frick's birth, before the post-Civil War boom was to make it a center for production of iron and steel. However, the earliest record of his purchase of a painting is not until after his first trip abroad in 1880. At the age of thirty, having made his initial million, Mr. Frick took several months off from work to travel in Europe, accompanied by Andrew Mellon, the twenty-six-

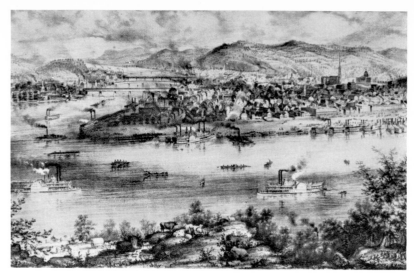

PITTSBURGH AND ALLEGHENY FROM COAL HILL 1849, detail from a lithograph by B. F. Smith, Jr.

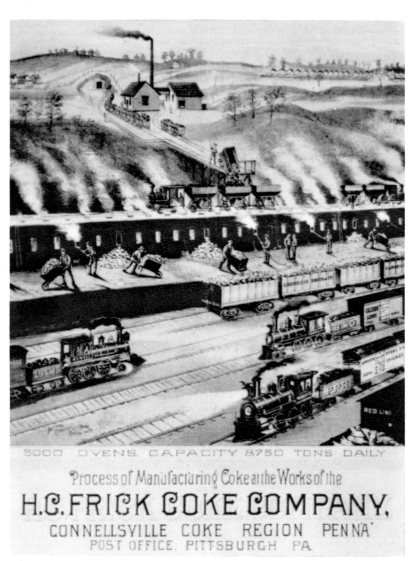

Detail from a lithograph advertising the H. C. Frick Coke Company.

year-old son of the Judge Mellon who had financed Mr. Frick's first industrial venture. It is interesting to speculate on the importance of this trip in shaping the taste of these two young men—the future founders of The Frick Collection and The National Gallery in Washington—and thus on its importance to the cultural life of the United States.

Mr. Frick's first recorded art purchase, in 1881, a small painting by Luis Jiménez entitled *In the Louvre,* may have been a souvenir of that trip; it is just the sort of anecdotal painting a young traveller might be expected to acquire.

In the same year, Mr. Frick married Adelaide Howard Childs, and soon thereafter he bought "Clayton," the large brick house which became their permanent home in Pittsburgh and which was soon to be filled with Mr. Frick's growing art collection. The following year, 1882, the Frick firm was reorganized as the H. C. Frick Coke Company, and in 1889, extending his interests to steel, Mr. Frick was made Chairman of the Board of Carnegie Brothers. During the 1880s, only two additional purchases of paintings are recorded, both by artists little known today. However, by 1895 Mr. Frick was buying steadily, averaging until the turn of the century more than a purchase a month.

The story of The Frick Collection can perhaps best be told by a chronological review of Mr. Frick's collecting of paintings. His taste during this early period ran to contemporary artists, chiefly French: pictures by Bouguereau, Breton, Jacque, Bonheur, Cazin, Mauve, Raffaëlli, Ziem, and Alma-Tadema, as well as numerous Barbizon School landscapes (including Daubigny's *Washerwomen,* which, bought in 1896, is the earliest purchase still remaining in The Frick Collection). Mr. Frick's daughter speaks of delightful Sunday afternoon visits during these years to the studio of Joseph R. Woodwell, where her father and Mr. Woodwell discussed the Barbizon painters. Mr. Woodwell had lived in France, knew the outstanding members of the Barbizon School, and was a friend of Pissarro and other Impressionists. Along with the above-mentioned acquisitions, which reflected popular contemporary taste, Mr. Frick bought a portrait by Nattier and one by Rembrandt, as well as several by English eighteenth-century artists.

With the new century came the formation of the United States Steel Corporation, in which Mr. Frick played a key role. After this he began to withdraw from active industrial management and to devote more time to his investments, which were soon to include vast holdings in railway stock. At this same time his art collection was growing increasingly important, and occupied a great deal of his time. Although he still occasionally bought a Ziem or a Mauve, a Corot, a Millet, or a Diaz, English portraits and Dutch seventeenth-century paintings began particularly to attract him. In 1901 he bought the first of his several Turners, the first of the three Vermeers to enter his collection, and a Monet landscape. During the next years he added, among other works, a Hobbema, a Cuyp, a ter Borch, and portraits by Lawrence, Reynolds, Romney, and Gainsborough. In 1905 he bought El Greco's *St. Jerome,* the portrait of *Ottaviano*

H.C. Frick at twenty-one years of age, when his interest in art was first recorded.

H.C. Frick at thirty years of age, photographed in Paris during his first trip to Europe.

H.C. Frick at sixty years of age.

Canevari, which was his first Van Dyck, and Titian's *Pietro Aretino,* his first Italian Renaissance picture. The Vermeer and the El Greco were most unusual acquisitions, for to the best of our knowledge there was at that time only one work by each of these artists in an American museum, and only one or two more existed in American private collections.

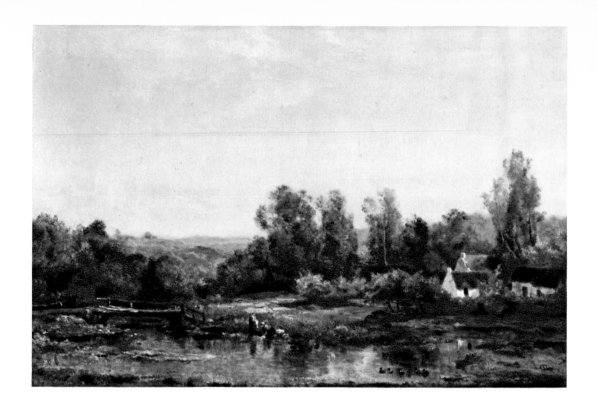

CHARLES-FRANÇOIS DAUBIGNY (1817-1878)
THE WASHERWOMEN
Oil, on canvas
20⅞ × 31 ½ in. (53 × 80 cm.)
This painting is the earliest of his acquisitions that
Mr. Frick bequeathed to the Collection.

In the fall of 1905, Mr. Frick rented a house in New York, after abandoning plans for a new house and gallery in Pittsburgh because of the potentially hazardous smoke from the steel mills. For the next nine years, Mr. and Mrs. Frick occupied the former Vanderbilt residence at 640 Fifth Avenue, which was undoubtedly chosen because it contained a large picture gallery suitable for displaying his expanding collection. Among the most important acquisitions of these years were Rembrandt's *Self-Portrait* (1906), the anonymous French fifteenth-century *Pietà* (1907), Constable's *Salisbury Cathedral* (1908), El Greco's *Purification of the Temple* (1909), the Van Dyck portraits of *Frans* and *Margareta Snyders* (1909), Rembrandt's *Polish Rider* (1910), Velázquez' *Philip IV of Spain* (1911), a second Vermeer, the *Officer and Laughing Girl* (1911), Holbein's *Sir Thomas More* (1912), two Veroneses, *The Choice of Hercules* and *Wisdom and Strength* (1912), Van Dyck's portrait of *The Earl of Derby, His Wife and Child* (1913), and El Greco's portrait of *Vincenzo Anastagi* (1913).

These acquisitions were all of exceptional quality and established him as a major collector; indeed, they are today among the highlights of the Collection. Of special interest to the story of Mr. Frick as collector is the French fifteenth-century *Pietà,* not only because it was a rare acquisition, but also because it had been brought to Mr. Frick's attention by Roger Fry. Mr. Fry was Curator of Paintings at The Metropolitan Museum of Art in 1906–07, and long after his return to London was retained as adviser to the Metropolitan. He also seems to have kept in touch with

important New York collectors, including Mr. Frick. In 1910 it was he whom Mr. Frick commissioned to go to Poland to negotiate the purchase of *The Polish Rider,* and we know that he later advised on the purchases of the Holbein portrait of *Sir Thomas More* and the two Veronese allegories.

During nearly half a century of collecting, Mr. Frick must have sought or been proffered advice by many associates and dealers, but he seems to have made his own decisions on purchases, and usually only after lengthy consideration. Pictures were often on approval for many months while he studied them in their relation to his other paintings and judged their appropriateness to a residential setting—a procedure that accounts, in part, for the harmony of The Frick Collection as viewed today. He also continued to improve his collection by disposing of or exchanging earlier purchases for works of higher quality.

Among the art dealers, Mr. Frick favored Knoedler and Company. Roland Knoedler and Charles Carstairs of that firm were both friends and advisers, and Mr. Frick acquired more paintings through them than through any other source. At times Knoedler was acting for others, particularly for European agents, though from the beginning Mr. Frick had also made acquisitions directly from dealers abroad. The role of Joseph Duveen has been exaggerated, for Mr. Frick's first purchase from Duveen was not made until 1910, by which time he had set his course as collector and made many of his most brilliant acquisitions. After moving into his new residence at Seventieth Street and

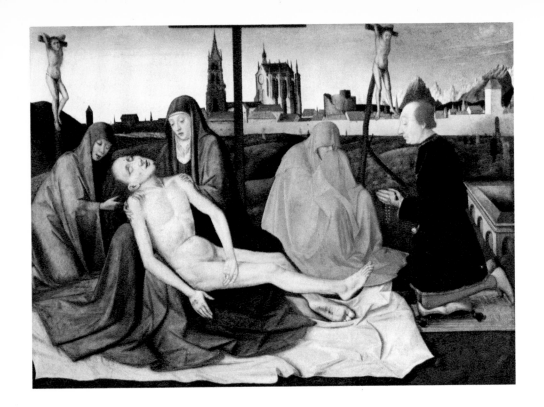

Fifth Avenue, Mr. Frick did purchase from Duveen his best Hals portrait (the *Portrait of a Man* formerly identified as Admiral de Ruyter), Gainsborough's unusual *The Mall in St. James's Park,* and the Fragonards and Bouchers. But at about the same time he was purchasing from other dealers, particularly from Knoedler, numerous paintings which also seemed destined for the new residence—paintings such as the Veronese allegories and the two large Turners. Duveen's most significant role was in providing some of the furnishings and many *objets d'art* for this residence, acting as agent for Mr. Frick's purchase of the finest Renaissance bronzes, the Limoges enamels, and the Chinese porcelains from the Morgan collection; however, Mr. Frick's chief adviser in the selection of these purchases appears to have been Miss Belle da Costa Greene, who was later to become the first director of The Morgan Library.

The house at Seventieth Street and Fifth Avenue, now the permanent home of The Frick Collection, was constructed in 1913–14 on the former site of the Lenox Library, which had been incorporated in the newly constructed New York Public Library on Fifth Avenue at Forty-Second Street. The new residence for Mr. and Mrs. Frick was designed by Thomas Hastings of the firm of Carrère and Hastings, who were also the architects for the new public library building. The sculptured decorations were executed by Piccirilli Brothers, while the ground floor interiors were designed by Sir Charles Allom, of White Allom, London. This residence was planned as a setting for Mr. Frick's paintings, and its generous rooms provided ample space for the

additions he continued to make to his collection. Despite the outbreak of World War I, Mr. Frick managed in 1914 to buy more than a dozen paintings for his new home. These included three Goyas, three Whistlers, the two large Turners, and several other canvases, among them Degas' *Rehearsal,* Manet's *Bullfight,* and Renoir's *Mother and Children.* It is interesting to note that the Degas and the Manet were hung in Mr. Frick's sitting room on the second floor, along with El Greco's *Purification,* Carrière's *Motherhood,* and Turner's *Calais Harbor;* the fact that Mr. Frick chose to surround himself in his private quarters with these pictures is further evidence of the advanced taste shown earlier in his career as a collector.

From 1915 to the end of the war, Mr. Frick enriched his collection with drawings, prints, and a large number of porcelains, Limoges enamels, and Renaissance bronzes. In part these purchases were intended to complement his collection of paintings in its new setting, but there is also reason to believe that Mr. Frick's interests as a collector were widening, since there exists a set of architectural drawings by Carrère and Hastings for the construction of additional galleries to the east of his picture gallery, including a large two-storied room designated specifically for sculpture. He bought fewer pictures, but among them were some of his finest acquisitions. These included the celebrated series of Fragonard canvases called *The Progress of Love,* which were set into the walls of the drawing room, and the Boucher panels of *The Arts and Sciences,* which were installed on the second floor in Mrs. Frick's sitting room. Other important

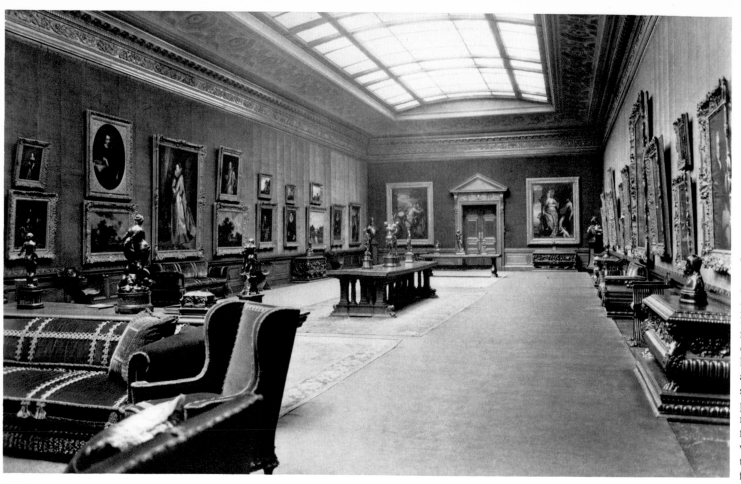

The West Gallery in the 1920s, before the Collection was opened to the public. An important feature of Mr. Frick's new residence, the gallery was designed to accommodate his growing collection and provided a spacious setting for such large pictures as the two Veronese allegories seen at the far end, flanking the doors which originally opened to the Enamel Room (see further discussion, p.60).

purchases during these years included Giovanni Bellini's *St. Francis in Ecstasy,* Titian's *Man in a Red Cap,* Bronzino's portrait of *Lodovico Capponi,* Van Dyck's *Sir John Suckling,* and Gainsborough's *The Mall in St.James's Park.*

Mr. Frick's last purchase, the only one recorded for 1919, the year of his death, was Vermeer's *Mistress and Maid.* The Vermeer joined Rembrandt's *Self-Portrait,* Holbein's *Sir Thomas More,* the Velázquez, and the Giovanni Bellini in the list of Mr. Frick's favorites, and it was while showing his final acquisition to a friend that Mr. Frick reportedly stated that he wanted his collection to serve as his monument. The idea of forming a collection and bequeathing it to the American public was probably inspired by an early visit to The Wallace Collection, which was left to the British nation in 1894, and there are indeed notable similarities between the two collections. The plans for creating a public gallery must have been firmly in Mr. Frick's mind by the time he built the new house at Seventieth Street. In a letter written during the war years, he raised the question whether anyone should at that time invest so much in works of art, but he reasoned that he was justified in doing so because he contemplated leaving his collection as a gift to the public.

At his death, Mr. Frick bequeathed in trust his residence and his works of art to establish a public gallery of art, to be known as The Frick Collection, "for the use and benefit of all persons whomsoever." It was his wish that the Collection continue forever to be shown in the residential setting which he had created. Frederick Mortimer Clapp, the organizing director of the Collection, is to be credited with successfully undertaking the difficult task of making a private residence into a public gallery. In subsequent years, with the position of The Frick Collection firmly established as a public gallery of art, it has been the privilege of the succeeding directors to emphasize even more the residential setting, where the presence of fresh flowers in the various rooms, the ticking of clocks, the absence of display cases, and the minimal use of restraining barriers preserve a lived-in quality despite the public use and enjoyment of the building.

In addition, Mr. Frick left an endowment, the income of which was to be used for the maintenance of the Collection and for any necessary alterations to the building. He also made an unusual provision permitting the use of a portion of the income from the endowment for the continued acquisition of works of art. This provision was the culminating gesture of a collector both adventurous and perfectionist by nature. We know that Mr. Frick, during his lifetime, attempted unsuccessfully to acquire such pictures

as Holbein's portrait of *The Duchess of Milan,* Velázquez' *Portrait of Innocent X,* and the Donne altarpiece by Hans Memling. Since his death, of course, it has not been possible for the Trustees to acquire these particular paintings, but they have been able to add to the Collection notable paintings by such artists as Duccio, van Eyck, Piero della Francesca, and Ingres. These later acquisitions have been so much of the quality and in the character of the original collection that few visitors are aware of this far-sighted and generous provision which so contributes to the continuing vitality of the Collection. The Trustees have followed Mr. Frick's policy of buying works of highest quality as they became available, rather than of "filling gaps." As compared to the average art museum The Frick Collection does not attempt to be an encyclopedia of art history, but rather an anthology of selected works of art of exceptional interest.

Mr. Frick's will also allowed for alterations and additions to the building, and after the death of Mrs. Frick in 1931 the house was remodelled to serve its new function as a public gallery. The carriage court was converted to form an interior garden court, and two galleries, the Oval Room and the East Gallery, were added in the area where Mr. Frick had planned an extension of galleries. A small assembly room was also added; here, autumn through spring, lectures by staff members and visiting scholars are offered daily, and concerts of chamber music are performed occasionally—thus fulfilling the founder's express purpose of "encouraging and developing the study of the fine arts and of advancing the general knowledge of kindred subjects." The Collection's educational activities are planned for an adult public and for university students in art history, especially those engaging in advanced studies. A symposium for graduate students is held annually, jointly sponsored by The Frick Collection and the nearby Institute of Fine Arts of New York University. The Frick Art Reference Library, which was founded by Miss Helen C. Frick in memory of her father, and which adjoins the Collection building, provides unusual research facilities for students, scholars, and connoisseurs, as well as for the staff of the Collection.

The official opening of The Frick Collection as a public art gallery on December 16, 1935, was greeted by a chorus of critical praise, not only for the excellence of the works of art and their setting, but also for the precedent established in art philanthropy in the United States in making a great private collection available to the public intact and in its original surroundings. Since the opening more than five million visitors have come to the Collection from the United States and all parts of the globe; the attendance in recent years has averaged more than eight hundred a day. Man-

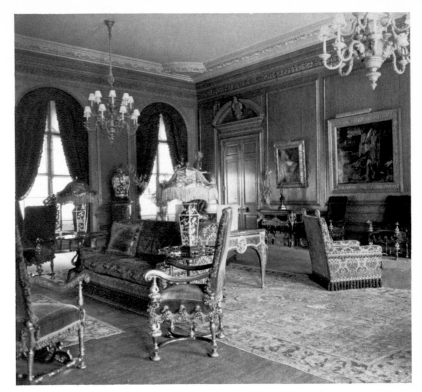

The Living Hall in the 1920s.

hattan residents who come frequently to the Collection consider it *their* gallery, and many diplomats, connoisseurs, and businessmen from Europe, Asia, and throughout the Americas make it a part of their every visit to New York. It is hoped that this book will provide a souvenir for all past and present visitors, and enjoyment to others, furthering Mr. Frick's wish that his collection be for the "use and benefit of all persons whomsoever."

Harry D. M. Grier
DIRECTOR
THE FRICK COLLECTION

Additions to the original building are indicated as shaded areas.

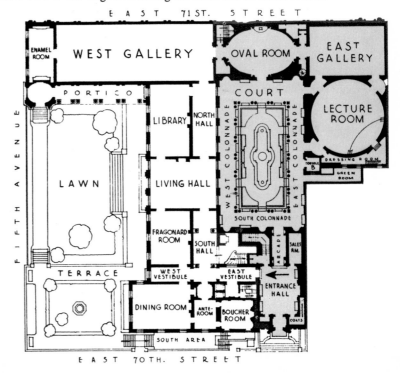

The South Hall

With a taste shared by great collectors of the past, Mr. Frick preferred to display his collection in a personal, eclectic fashion distinct from the customary museum tendency towards classification. Works of art of various periods and countries were freely mixed, and this heterogeneous disposition has been continued to the present day. Occasionally works of art are installed in different locations in the galleries or are removed temporarily and replaced by others from a small reserve.

The view of the South Hall shown below includes a typical range of styles and objects in the first exhibition area the visitor enters. Two canvases by Vermeer—the *Officer and Laughing Girl* and the *Girl Interrupted at Her Music*—flank Turner's *Fishing Boats Entering Calais Harbor,* the somber coloring of which is echoed in a unique blue Turquin marble console designed by Bélanger, with mounts by Gouthière. The dark "Mazarine" blue Yung Chêng porcelain jars on the console dramatically extend the scale of blues, which are repeated in the brilliant needle-point tapestries (about 1700) of the two armchairs. Across the South Hall, Corot's *Boatman of Mortefontaine* hangs over a sofa covered in the same "point de Saint-Cyr" tapestry as the chairs. At the north end of the hall, Boucher's portrait of his wife (p. 14) faces a majestic *Coronation of the Virgin* by Paolo and Giovanni Veneziano.

The two paintings by Vermeer displayed in the South Hall belong to an extraordinary group of three canvases by this artist, whose total *oeuvre* is generally considered to be less than forty. Mr. Frick was among the earliest American collectors to acquire paintings by Vermeer, who had been rediscovered by Théophile Thoré in the 1860s. His first purchase, the *Girl Interrupted at Her Music,* was acquired in 1901, followed by the dazzling *Officer and Laughing Girl* and the late, unfinished *Mistress and Maid* (p. 79).

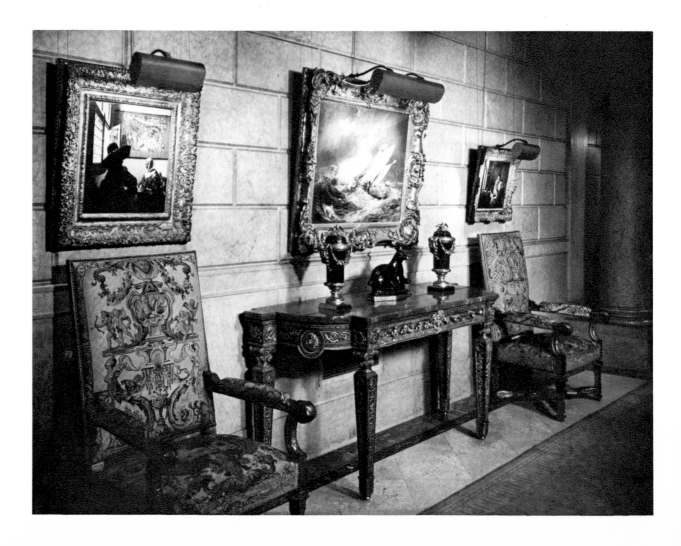

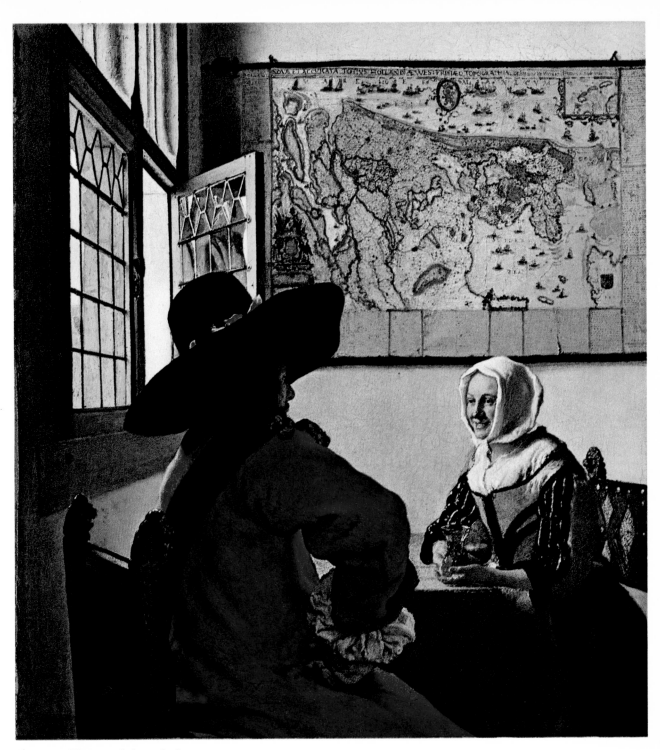

JOHANNES VERMEER (1632–1675)
OFFICER AND LAUGHING GIRL
Oil, on canvas
19⅞ × 18⅛ in. (50.5 × 46 cm.)

In this relatively early work Vermeer transforms his subject of a girl entertaining her suitor—a popular theme in Dutch painting—into a remarkable visual evocation of light-filled spaces and of surfaces touched with light. The map of Holland in the background is based on one published in 1621 and used by the artist in several paintings. The disproportionate scale of the two figures, with the officer towering over the girl across the table, is also a recurrent feature in Vermeer's paintings; it may be the result of the distortions caused by a type of camera obscura which the artist used to transfer his visual data to canvas.

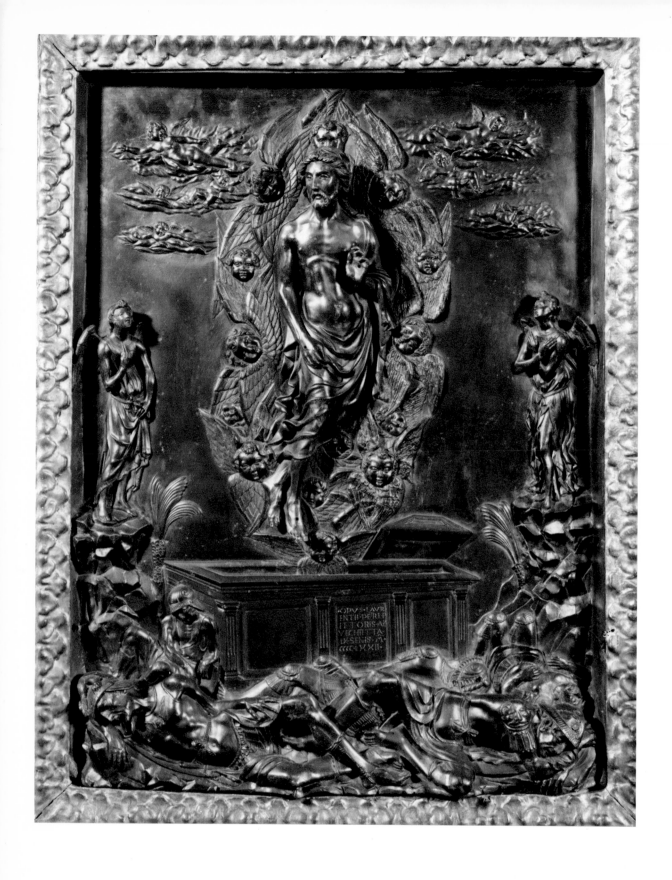

Vecchietta (c. 1412–1480)

THE RESURRECTION

Bronze
Height: 21⅜ in. (54.3 cm.);
Width: 16¼ in. (41.2 cm.)

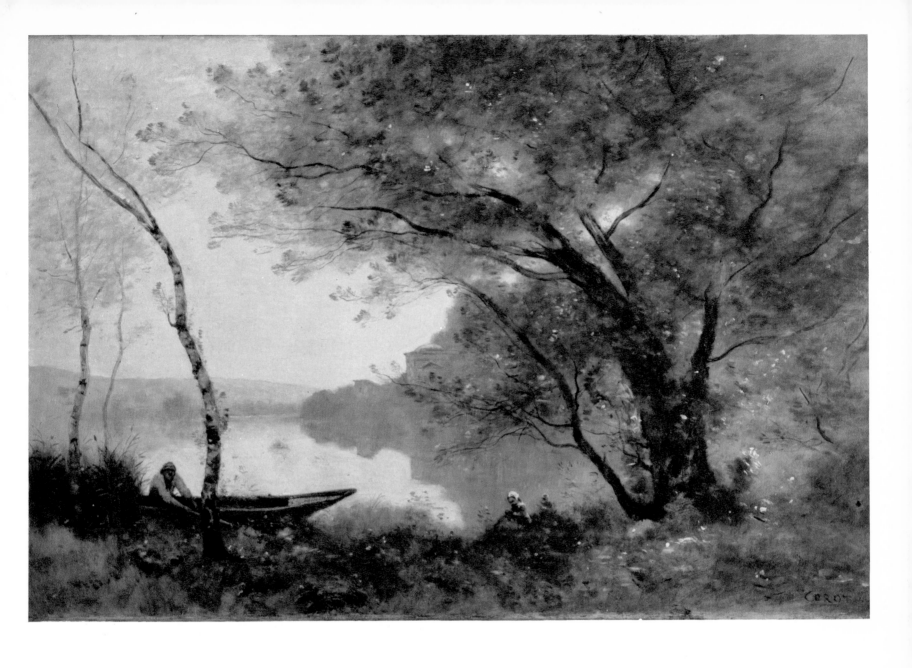

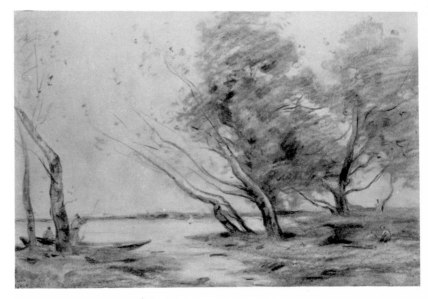

JEAN-BAPTISTE-CAMILLE COROT
(1796–1875)
THE BOATMAN OF MORTEFONTAINE
Oil, on canvas
24 × 35⅜ in. (60.9 × 89.8 cm.)

JEAN-BAPTISTE-CAMILLE COROT
STUDY FOR THE BOATMAN
OF MORTEFONTAINE
Charcoal, on cream paper
16⅛ × 23⁷/₁₆ in. (41 × 59.7 cm.)

In 1916 Mr. Frick acquired fifteen paintings by François Boucher, and in 1937 the portrait of the artist's wife was added to this important group of pictures.

Marie-Jeanne Buseau, painted by her husband in 1743 when she was in her twenties, often served as a model for Boucher in his mythological compositions. Among the fascinating details of interior furnishings in this portrait are evidences of the eighteenth-century enthusiasm for chinoiserie, seen in the seated porcelain figure, teapot, cups, and saucers displayed on the small lacquered étagère. Many similar objects are listed in the inventory of Boucher's effects.

The Four Seasons, of which *Winter* is here reproduced, were executed in 1755 for Madame de Pompadour and show Boucher in a more conservative and public manner—his pastoral genre, following the *fête galante* iconography established by Watteau early in the eighteenth century. Probably intended to be used as overdoors, these compositions were popularized by Jean Daullé's engravings. The Boucher *Seasons* hang in the West Vestibule, adjacent to the South Hall.

FRANÇOIS BOUCHER (1703–1770)
MADAME BOUCHER
Oil, on canvas
22½ × 26⅞ in. (57.2 × 68.3 cm.)

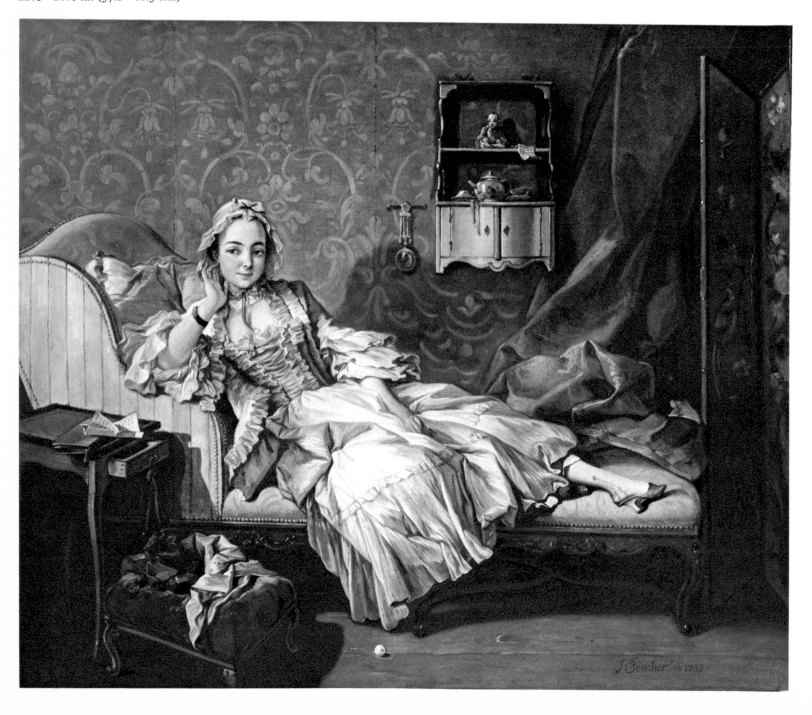

FRANÇOIS BOUCHER

WINTER

Oil, on canvas

22⅜ × 28¾ in. (56.8 × 73 cm.)

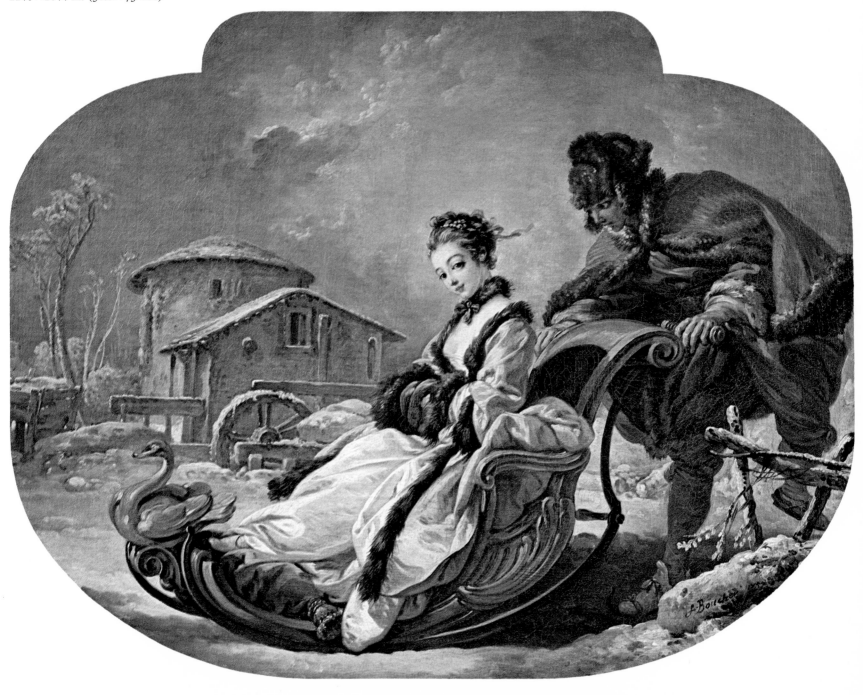

At lower left stands a tall clock dated 1767, the case executed by Lieutaud and the bronze ornaments by Philippe Caffiéri. The clock may possibly have been commissioned for the Dauphin, the future Louis XVI. A similar clock, in ebony rather than tulipwood, is in the Musée de Versailles. Renoir's *Mother and Children* of 1874–76 hangs in the niche which houses the organ console. On the staircase landing, beneath the richly decorated organ front, stands a Régence commode bearing two Ch'ien Lung covered jars. The commode is flanked by chairs covered in Beauvais tapestry of about 1772, and by a pair of monumental candelabra, in gilt bronze and lapis lazuli, which date from about 1785.

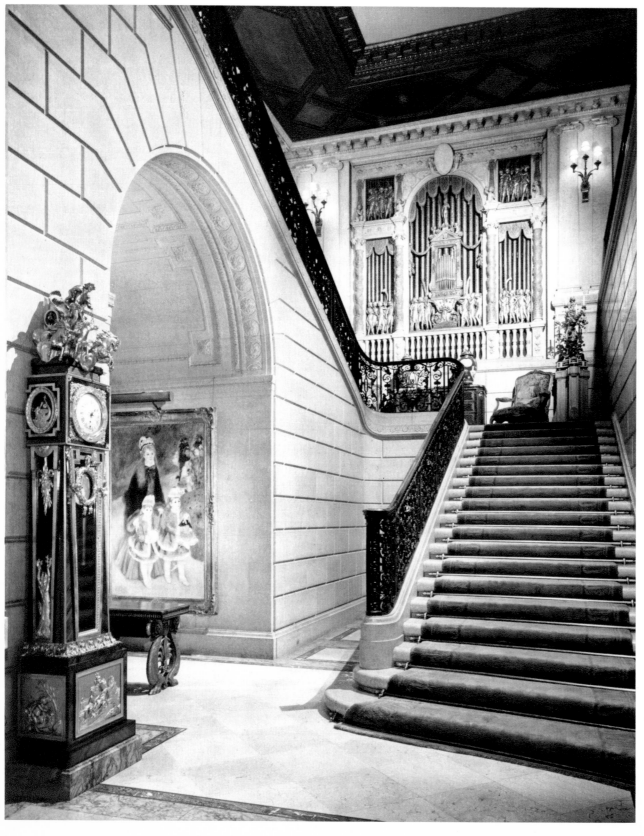

THE STAIRCASE

16

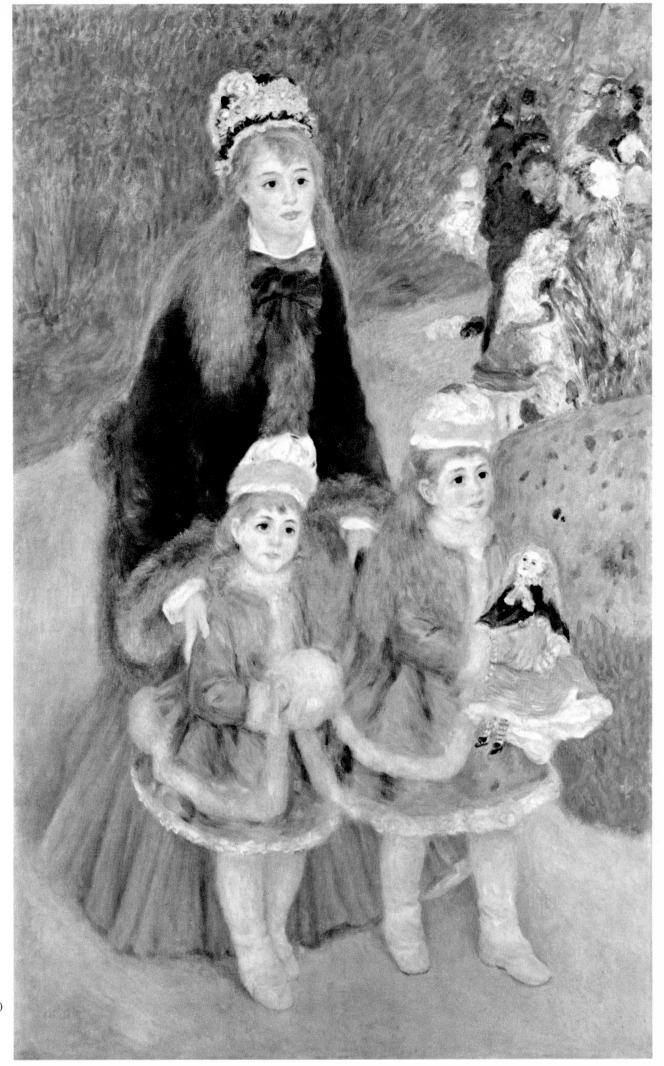

PIERRE-AUGUSTE RENOIR (1841–1919)
MOTHER AND CHILDREN
Oil, on canvas
67 × 42⅝ in. (170.2 × 108.3 cm.)

The Boucher Room

The Boucher Room was previously installed on the second floor of the house as Mrs. Frick's sitting room; for that reason her oval portrait has been placed in the center of the room, on a writing table by Riesener. The eight panels comprising *The Arts and Sciences* which decorate the walls were painted by Boucher for one of Madame de Pompadour's residences—the Château de Crécy near Chartres, rebuilt by Lassurance about 1746–48. They apparently remained in the château until just before its destruction in 1830. Complementing them is a distinctive group of decorative art objects: examples of Vincennes and Sèvres porcelain, including a garniture of three covered jars in marbled "myrthe" pattern decorated with scenes after Teniers; the mahogany writing table by Riesener; and, to the right of the chimney piece, an elaborate dressing table by Carlin. This latter piece has compartments for cosmetics, and its upper section separates to serve as a bed table with a mirror and reading stand; it can also be used flat as a small writing desk. In addition there is furniture by Louis-Noël Malle, André-Louis Gilbert, and Mathieu-Guillaume Cramer. The panelling, chandelier, and upholstered furniture are modern.

MARTIN CARLIN (d. 1785)
LADY'S DRESSING TABLE (POUDREUSE)
Tulipwood, ebony, boxwood, and mahogany, with gilt-bronze mounts
Height: 31⅞ in. (81 cm.);
Length: 28 in. (71 cm.);
Depth: 15⅞ in. (40.3 cm.)

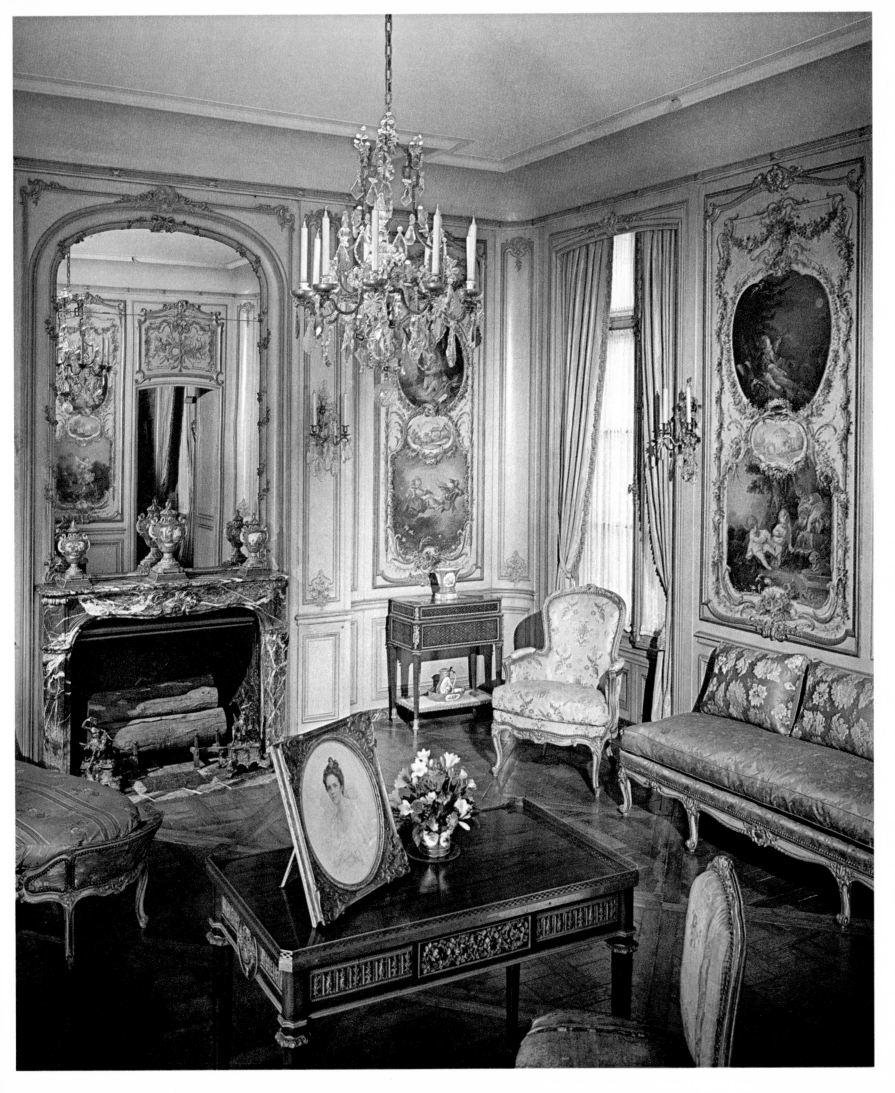

The *Arts and Sciences* clearly seem to refer to specific interests of Boucher's patroness, Madame de Pompadour, just as the artist's nearly contemporary decorations for the Salle du Conseil at Fontainebleau (1753) referred to particular aspects of Louis XV's government. *Painting and Sculpture* and the themes relevant to the theater, the dance, music, and literature allude to the Marquise's well-known interest in the arts, while *Hydraulics* was an apt subject for her château, which was famed for its waterworks, and *Chemistry* could well refer to the Marquise's direct interest in the Vincennes porcelain manufactory—later to be transferred to Sèvres. The use of children mimicking the activities of men was not original with Boucher, but here the artist imbues these subjects with his own peculiarly playful wit—demonstrated in the exploding chemical experiment and in the vain efforts of a young astronomer to study the moon through the wrong end of his telescope.

FRANÇOIS BOUCHER (1703–1770)
PAINTING AND SCULPTURE
Oil, on canvas
85½ × 30½ in. (217.2 × 77.5 cm.)

FRANÇOIS BOUCHER
CHEMISTRY – DETAIL

The Dining Room

The furniture and painted panelling in the Dining Room are modern, designed in the spirit of the English state dining rooms of the eighteenth century. Adjoining the Boucher and the Fragonard Rooms, the Dining Room demonstrates clearly that Mr. Frick's catholic taste was equally drawn towards English period design. With the exception of Gainsborough's unusual landscape, *The Mall in St. James's Park,* the paintings hanging here are all British portraits. Over the English eighteenth-century marble chimney piece hangs a portrait by John Hoppner (1758–1810) of *The Ladies Sarah and Catherine Bligh,* painted probably about 1790. Hogarth's *Miss Mary Edwards,* which originally hung in the Library where Mr. Frick's portrait is today, represents one of England's wealthiest heiresses, who was remarkable for her forthright, independent spirit. The brilliant scarlet of her dress is echoed in Reynolds' red-coated *General Burgoyne,* the ill-fated British commander who surrendered in 1777 to the Americans at Saratoga. Two monumental *famille rose* jars stand in the corners of the room by the windows facing the park. A set of four smaller Ch'ien Lung jars and some examples of English silver are placed on the serving tables. On the chimney piece a smaller pair of dark blue Yung Chêng jars in eighteenth-century French gilt-bronze mounts stand on either side of a Louis XVI clock with the movement by Ferdinand Berthoud.

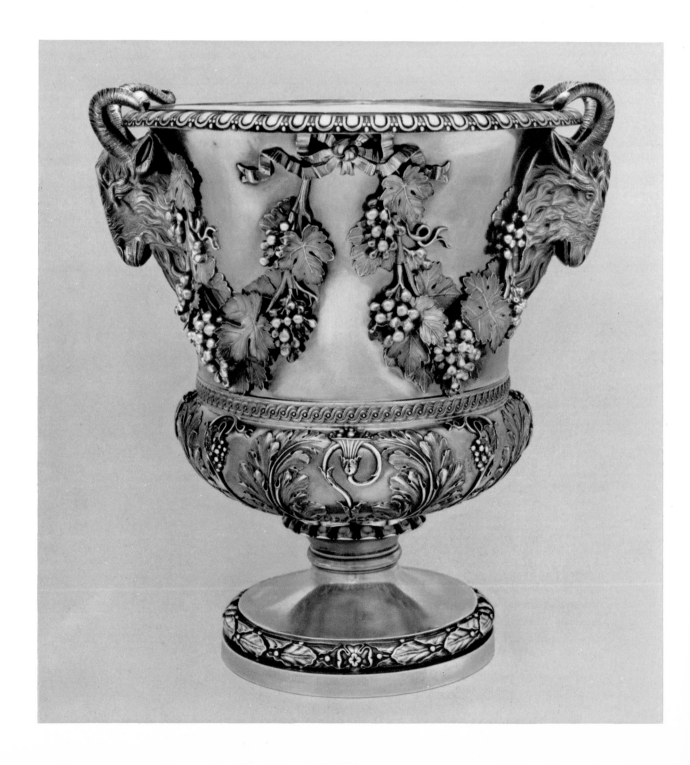

PAUL STORR (flourished 1792–1839)
WINE COOLER
Silver Gilt
Height: 11¼ in. (28.6 cm.);
Diameter: 9¼ in. (23.5 cm.)

THE DINING ROOM
Over the English eighteenth-century
marble chimney piece hangs a portrait
by John Hoppner (1758–1810) of
THE LADIES SARAH AND CATHERINE BLIGH,
painted probably about 1790. Below
it a pair of dark blue Yung Chêng
jars in eighteenth-century French gilt-
bronze mounts stand on either side of
a Louis XVI clock with the movement
by Ferdinand Berthoud.

The general enthusiasm of American collectors around 1900 for British eighteenth-century portraitists, particularly for Gainsborough, was shared to a degree by Mr. Frick. Three full-scale portraits, a half-length portrait of *Mrs. Charles Hatchett,* and *The Mall in St. James's Park* were acquired during his lifetime; the smaller portraits of *Richard Paul Jodrell* and *Grace Dalrymple Elliott* were added to the Collection in 1946. These pictures give a fairly complete idea of Gainsborough's development within the portrait genre. *Sarah, Lady Innes* (p. 53), painted in Bath in 1757, has the pert attitude and fresh character of the artist's early works, while the 1777 portrait of *The Hon. Frances Duncombe* (p. 101) demonstrates the mature artist's skill in the grand manner. In the simpler, full-length *Mrs. Peter William Baker* of 1783, Gainsborough explores in a more personal fashion the expressive possibilities of the landscape setting. In contrast to these characteristic portraits, Gainsborough's *The Mall in St. James's Park* is a unique exercise, somewhat reminiscent of the French *fête galante.* Indeed it was described by the artist's contemporaries as being "in the manner of Watteau"—even as "Watteau far outdone."

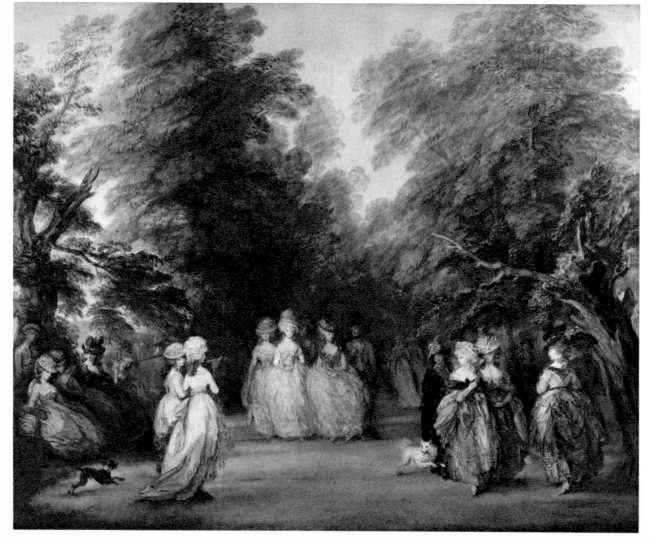

◁ THOMAS GAINSBOROUGH (1727–1788)
THE MALL IN ST. JAMES'S PARK
Oil, on canvas
47½ × 57⅞ in. (120.6 × 147 cm.)

THOMAS GAINSBOROUGH ▷
THE MALL IN ST. JAMES'S PARK – DETAIL

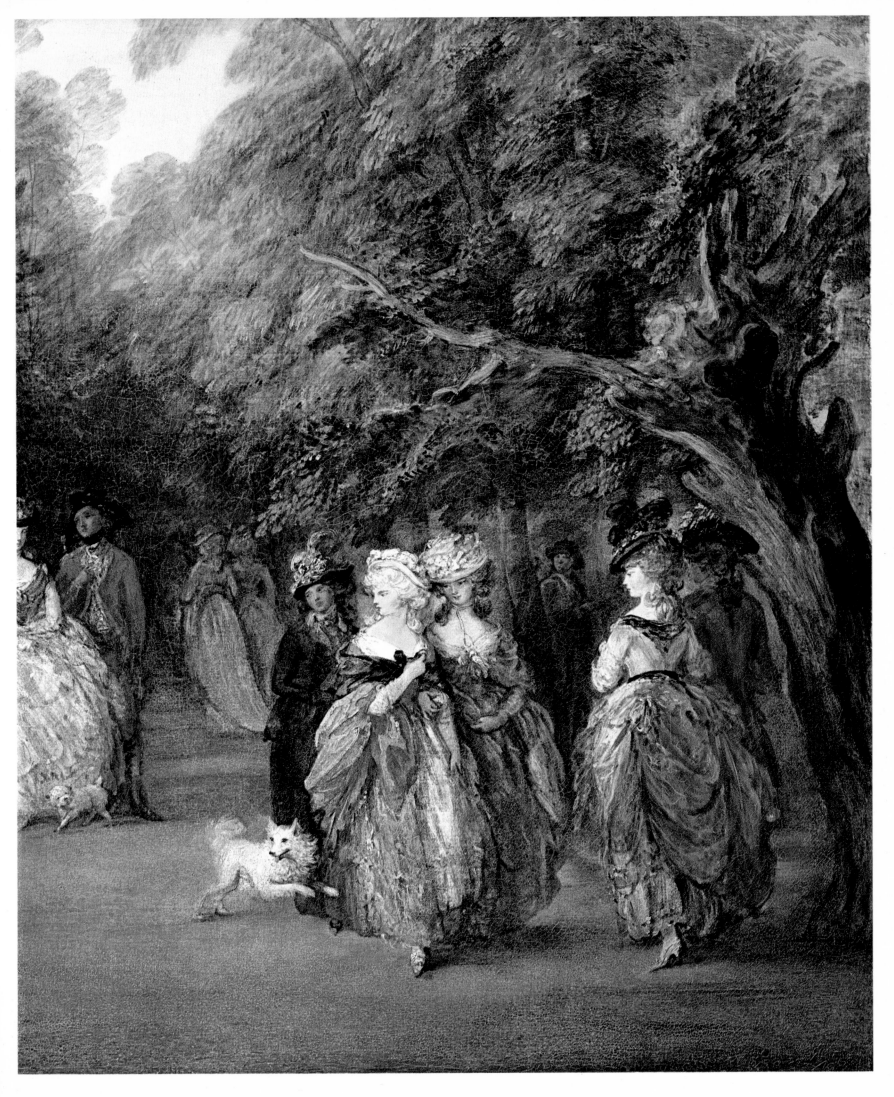

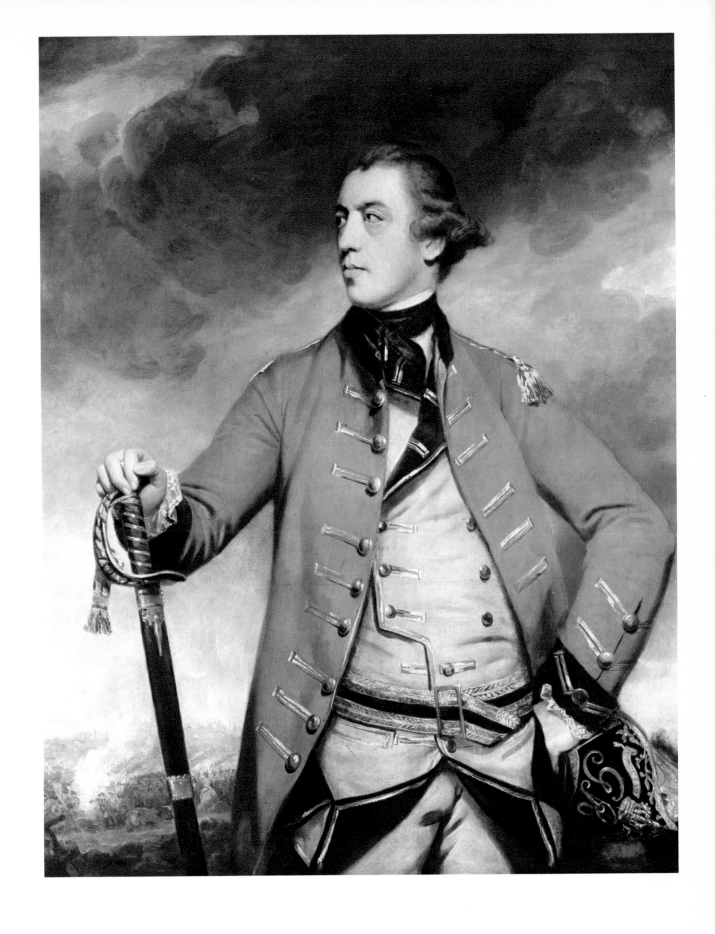

WILLIAM HOGARTH (1697–1764)
MISS MARY EDWARDS
Oil, on canvas
49¾ × 39⅞ in. (126.4 × 101.3 cm.)

SIR JOSHUA REYNOLDS (1723–1792)
GENERAL JOHN BURGOYNE
Oil, on canvas
50 × 39⅞ in. (127 × 101.3 cm.)

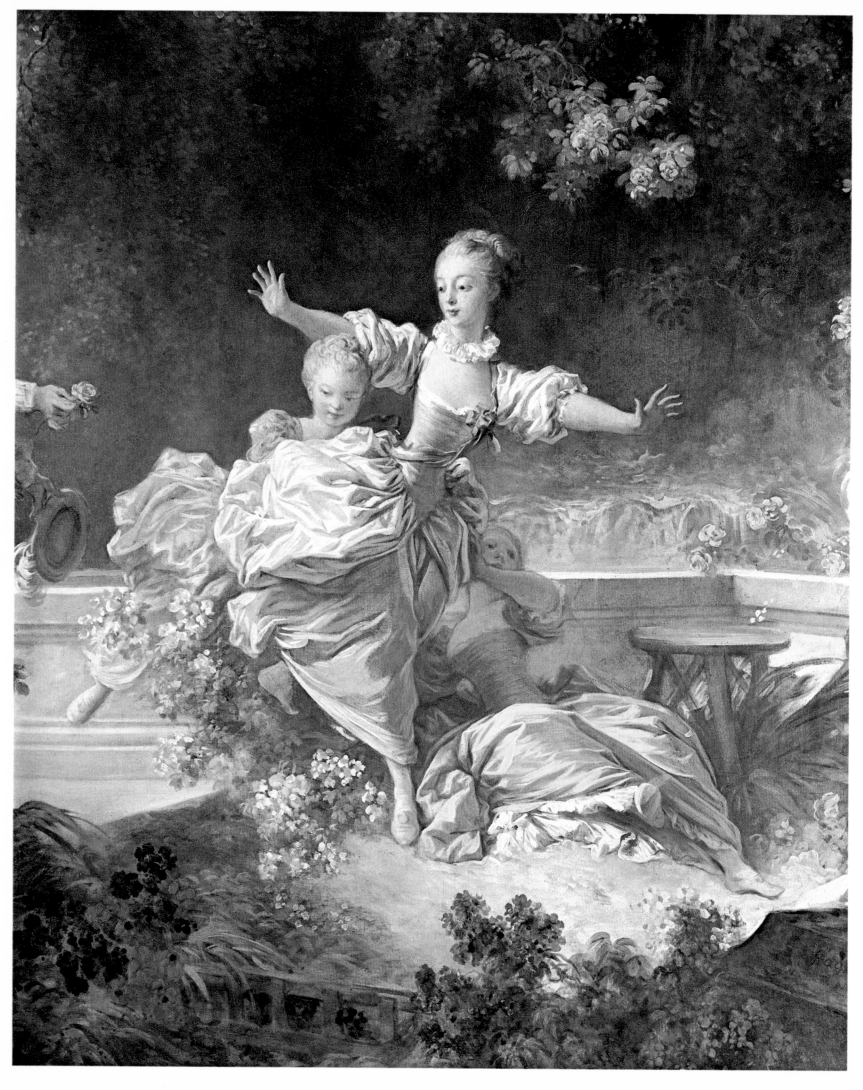

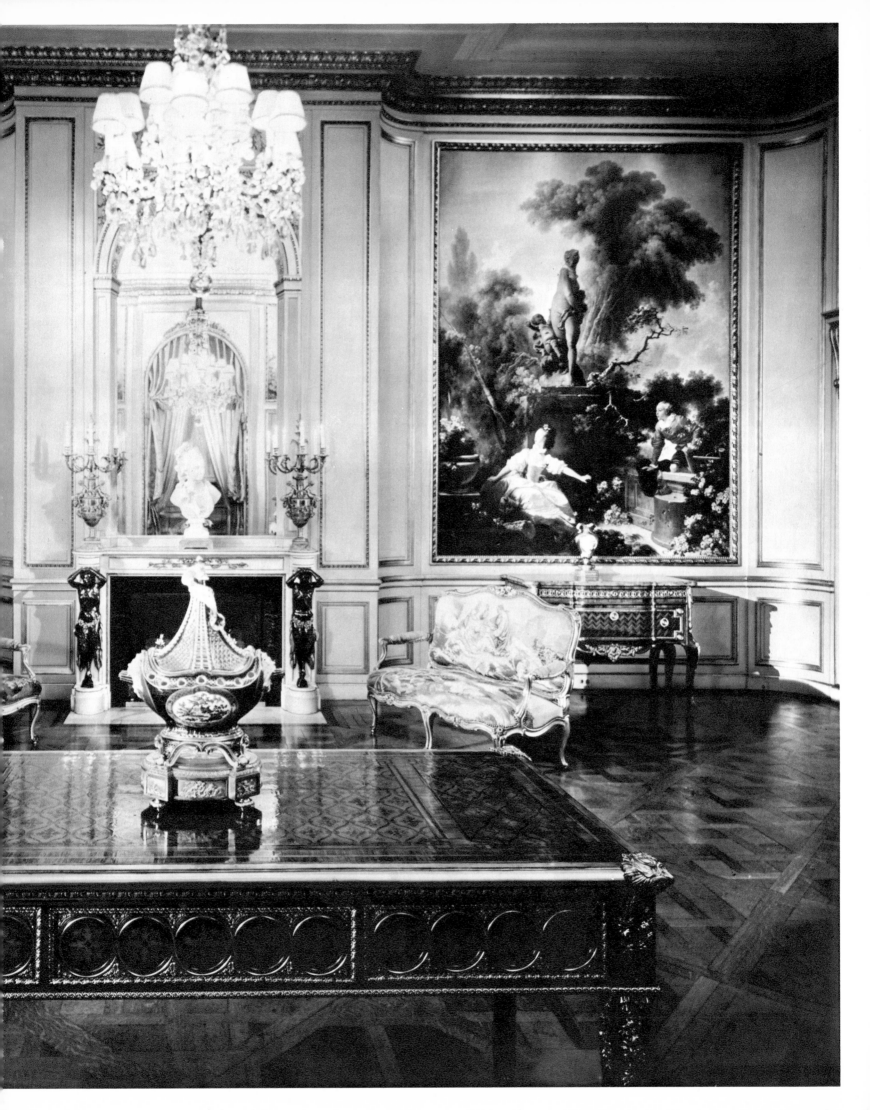

The Fragonard Room

This room is the setting for an ensemble of canvases by Fragonard and a remarkable group of French furniture of the eighteenth century. The four largest paintings constituted a series entitled *The Progress of Love,* executed between 1771 and 1773 for a new dining pavilion at Madame du Barry's château at Louveciennes. They are *The Pursuit, The Meeting, Love Letters,* and *The Lover Crowned.* Presumably because the exuberant rococo character of Fragonard's work was judged inappropriate in the severe classicizing setting of Ledoux's pavilion, the panels were rejected, although they had been installed briefly. Vien provided suitable replacements in a neoclassical style, and Fragonard retained his paintings until, in 1790, he returned to his native Grasse. There he installed the four Louveciennes panels in his cousin Maubert's house and painted additional panels to complete the series. With depictions of *Love Triumphant* and Love in such guises as *The Avenger, The Jester,* and *The Sentinel,* most of these later works develop the amorous theme of the original four, but with a general change in tone and style. With *Reverie,* for instance, the subject is subdued, even pathetic. Four long, narrow canvases representing hollyhocks completed the decorations at Grasse.

JEAN-HENRI RIESENER (1734–1806)
CHEST OF DRAWERS (COMMODE)
Satinwood, boxwood, tulipwood, and amaranth, with gilt-bronze mounts
Height: 37¾ in. (96 cm.);
Length: 56¾ in. (144 cm.);
Depth: 24⅝ in. (62.5 cm.)

On the chest of drawers:
CLAUDE MICHEL (CLODION)

SATYR WITH TWO BACCHANTES
Terracotta
Height: 18½ in. (46.9 cm.)

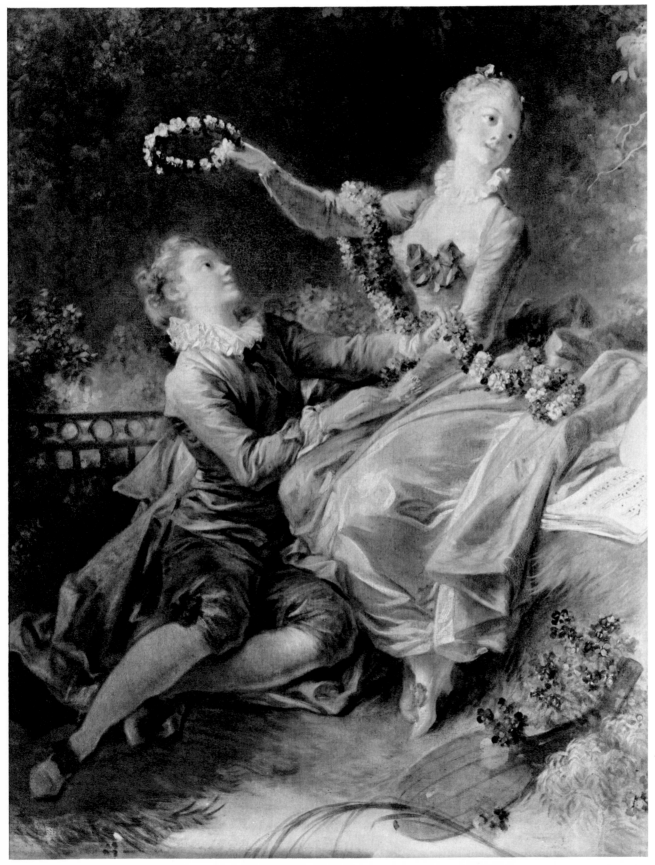

◁ Jean-Honoré Fragonard
THE LOVER CROWNED — DETAIL

Jean-Honoré Fragonard ▷
THE MEETING
Oil, on canvas
125 × 96 in. (317.5 × 243.8 cm.)

◁ JEAN-HONORÉ FRAGONARD (1732–1806)
THE PURSUIT – DETAIL

THE FRAGONARD ROOM ▷
THE LOVER CROWNED (left) and THE
MEETING (right), above chests of
drawers by Pierre Dupré; Houdon's
bust of the COMTESSE DU CAYLA on the
chimney piece; two canapés and an
armchair by Nicolas Heurtaut, with
Beauvais tapestry coverings designed
by Boucher; an oval sewing table by
Georges Jacob; in the foreground,
on a flat-top desk attributed to Bene-
man, a Sèvres pot-pourri vase
which forms a garniture with the two
vases on the chests of drawers.

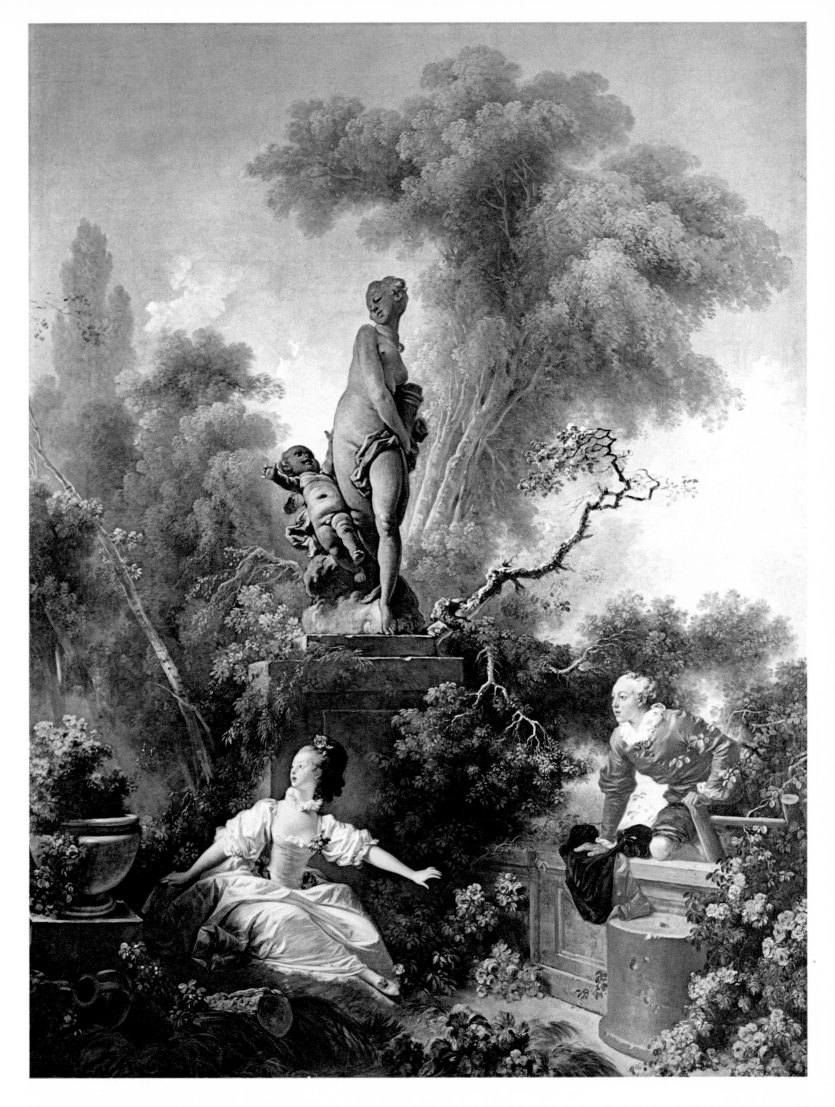

JEAN-HONORÉ FRAGONARD
REVERIE
Oil, on canvas
125⅛ × 77⅝ in. (317.8 × 197.1 cm.)

SÈVRES, shortly after 1756
POT-POURRI VASE
Soft paste porcelain on gilt-bronze base
Height: 21 in. (53.3 cm.)

The Living Hall

Because of its central location and the importance of the works of art exhibited in it, the Living Hall is the heart of The Frick Collection—its scale more private and intimate than that of the grand West Gallery. Richly panelled in oak, this room has three large windows to the east and west which provide views into the Garden Court on one side and across the lawn to Fifth Avenue and Central Park on the other. Exhibited here are Bellini's celebrated *St. Francis in Ecstasy* and five major sixteenth-century paintings by El Greco, Holbein, and Titian, along with the ensemble of Boulle furniture, the Renaissance bronzes, the porcelains, and the Isfahan carpet—a rich and characteristic sampling from the Collection.

BERNARD II VANRISAMBURGH
(flourished before 1765)

CABINET (BAS-D'ARMOIRE)

Ebony and lacquer, with gilt-bronze mounts
Height: 35⅛ in. (89.2 cm.);
Length: 47 in. (119.4 cm.);
Depth: 22 in. (55.9 cm.)

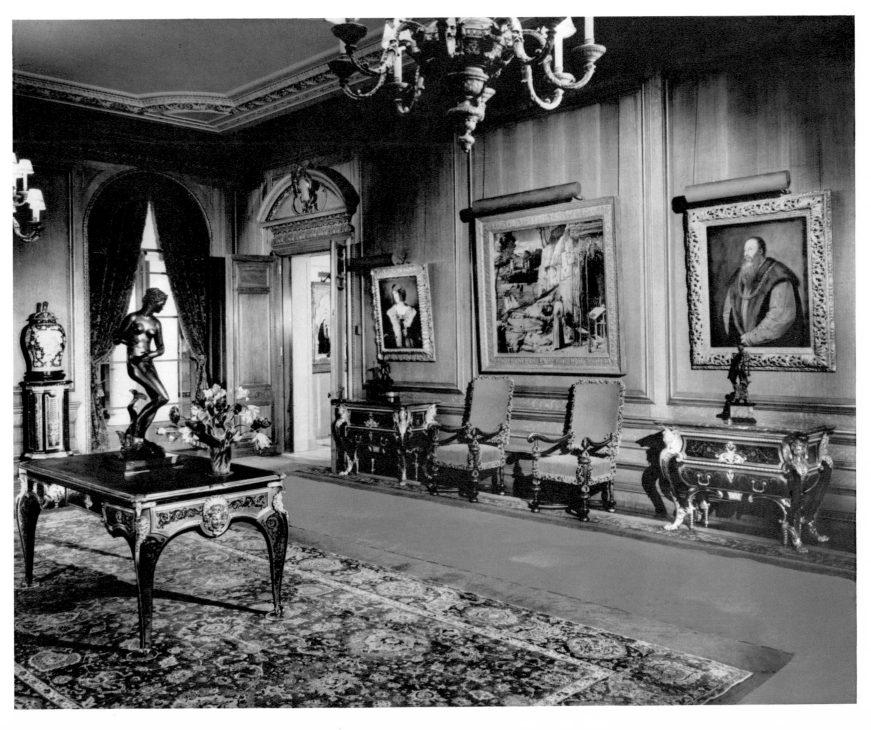

The scope and detail of the landscape setting of Giovanni Bellini's *St. Francis in Ecstasy* are integrally related to its meaning. In earlier and traditional depictions of the Saint receiving the Stigmata—the wounds of Christ's Crucifixion—artists included a seraph emanating rays which extended down to the Saint. Bellini employed a more naturalistic, yet transcendental, imagery of the path of light and even a suggestion of stirring winds descending diagonally from the upper left. His concentration on the eloquent landscape corresponds with the spirit of early Franciscan literature, including writings attributed to St. Francis himself, who spoke of his love for the sun, all living beings, and the phenomena of nature.

GIOVANNI BELLINI (c. 1430–1516)
ST. FRANCIS IN ECSTASY
Tempera and oil, on poplar panel
49 × 55⅞ in. (124.4 × 141.9 cm.)

GIOVANNI BELLINI ▷
ST. FRANCIS IN ECSTASY – DETAIL

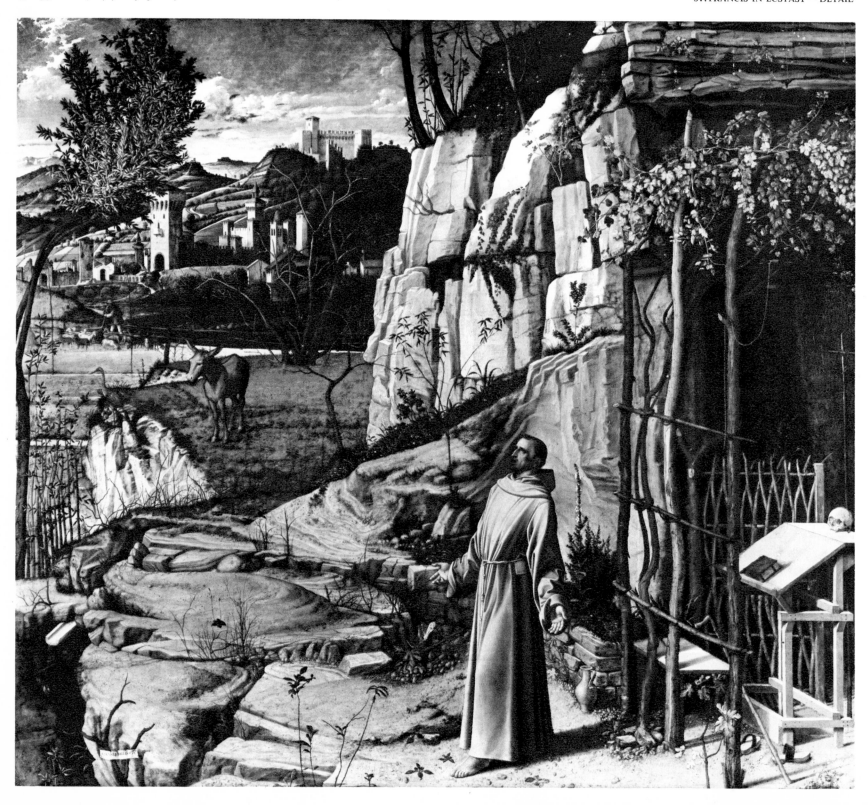

There are in The Frick Collection six Persian rugs of the floral variety made in Herat in the sixteenth century and commonly known as "Isfahans." In addition there are two Indian rugs, both made in the time of the Mogol emperor Shah Jahan (1628–58). The carpet illustrated in the detail below may be seen in the view of the Living Hall (p. 37). Other carpets in the Collection appear in views of the West Gallery (pp. 61, 80) and the East Gallery (p. 103).

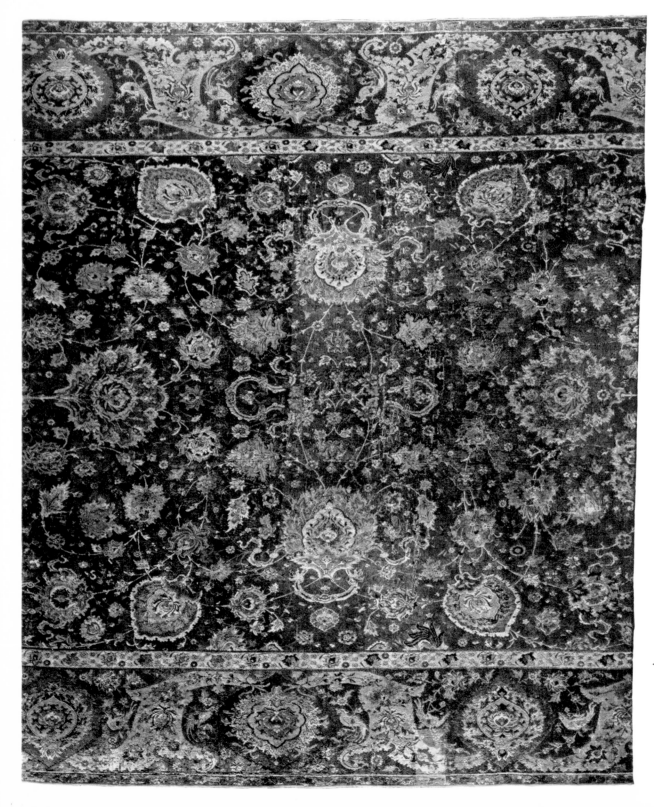

◁ Persian, Herat (so-called Isfahan)
CARPET – DETAIL

Domenikos Theotokopoulos ▷
(El Greco) (1541–1614)
ST. JEROME
Oil, on canvas
43½ × 37½ in. (110.5 × 95.3 cm.)

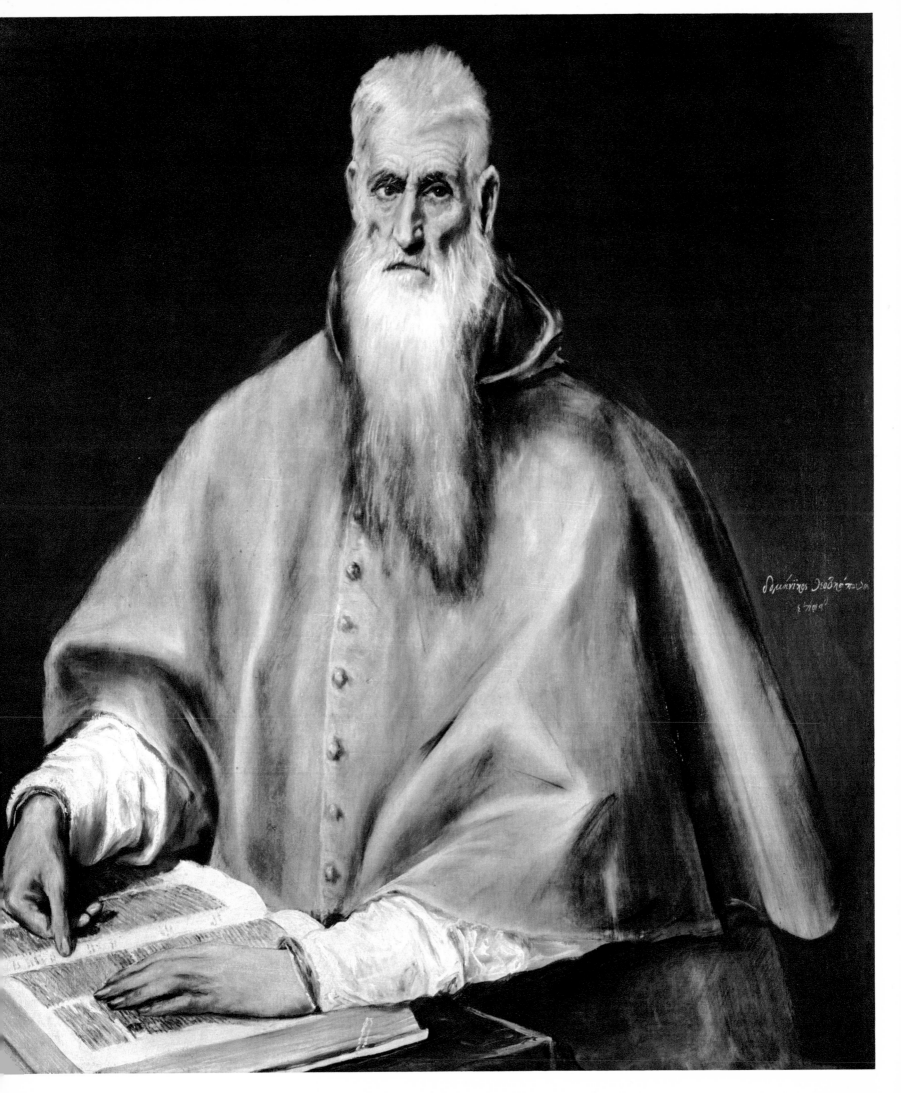

41

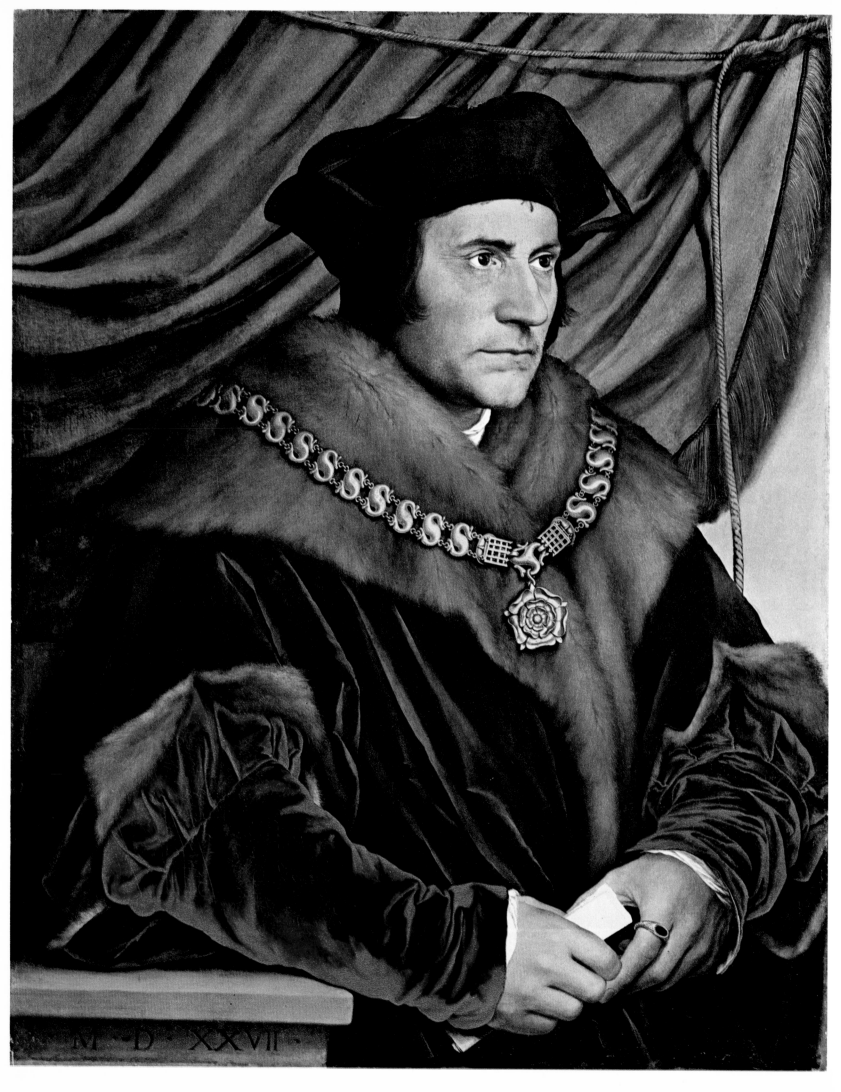

Two pairs of portraits by Holbein and Titian in the Living Hall offer extraordinary contrasts, not only of painterly styles but of human types. The chiselled, serene features of *Sir Thomas More,* so evocative of the stalwart character of Henry VIII's Lord Chancellor, confront the shifty, pinched ones of the man largely responsible for More's execution—*Thomas Cromwell.* Holbein painted the portrait of More in 1527, during his first visit to England, and later repeated this figure in his group portrait of the More family, a painting now lost but known from copies and from the study for the composition preserved in the Kunstmuseum, Basel. Across the room are portraits from the beginning and from the height of Titian's career: the romantic *Portrait of a Man in a Red Cap,* painted about 1516 under the influence of Giorgione, and the powerful *Pietro Aretino,* notorious author of letters, satires, verses, and comedies. The irrepressible force of Aretino's physical presence contrasts sharply with the hesitant gesture and dreamy gaze of the unidentified youth.

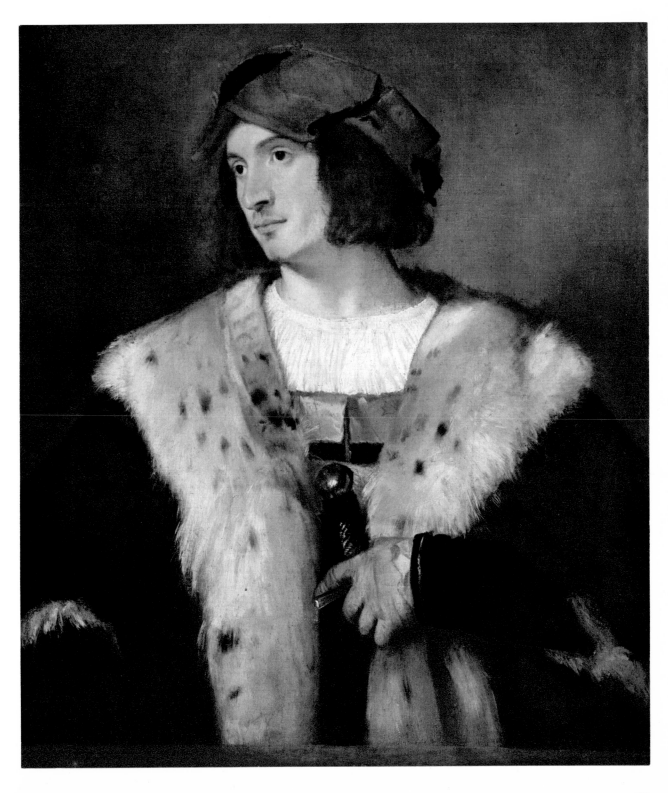

◁ Hans Holbein the Younger
(1497/98–1543)
sir thomas more
Oil, on oak panel
29½ × 23¾ in. (74.9 × 60.3 cm.)

Tiziano Vecellio (Titian) ▷
(1477/90–1576)
portrait of a man in a red cap
Oil, on canvas
32⅜ × 28 in. (82.3 × 71.1 cm.)

In the late seventeenth century André-Charles Boulle (1642?–1732) evolved a type of marquetry furniture which has been collected and copied almost continuously since his time. Set off with gilt-bronze mounts, his furniture usually bore patterns inlaid in ebony with tortoise shell, brass, and other metals. The history of the lasting taste for such furniture is neatly summarized in the Living Hall furnishings. Earliest in date are the central flat-top desk and the pair of pedestals supporting Yung Chêng vases, all three pieces probably from Boulle's own workshop. By the windows overlooking the terrace are two cabinets possibly executed in England in the nineteenth century in the manner of Boulle, and beneath the Titians are two extraordinarily rich chests which are copies of a famous, documented pair made by Boulle for Versailles. In addition, exhibited in the West Vestibule is a flat-top desk from Boulle's workshop which was repaired or sold during the late eighteenth century by Étienne Levasseur, whose mark it bears.

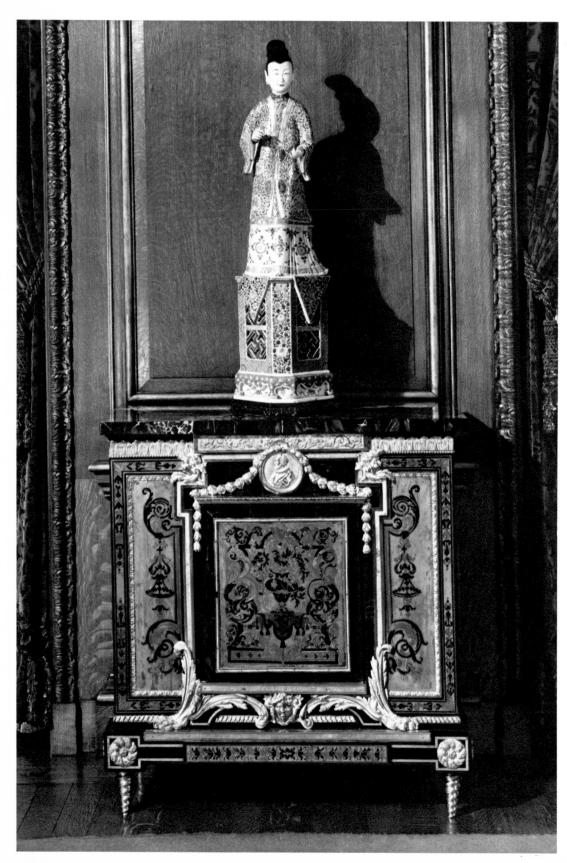

After A.-C. BOULLE
English, mid-nineteenth century
CABINET (MEUBLE D'APPUI)
Ebony, with marquetry of shell, copper, and pewter, and gilt-bronze mounts
Height: 39 in. (99 cm.);
Length: 37 in. (94 cm.);
Depth: 15¾ in. (40 cm.)

On the cabinet:
CHINESE PORCELAIN,
Reign of K'ang Hsi
FEMALE FIGURINE
Height: 38 in. (96.5 cm.)

After assembling, by 1915, the major portion of his paintings, Mr. Frick turned to sculpture. His earliest acquisitions for the Collection in that field came in 1915, with the largest number following in 1916; a few additional purchases were made before his death in 1919, and a small number of sculptures have been acquired subsequently by the Trustees. Following the death of J. Pierpont Morgan in 1914, Mr. Frick was able to acquire from the Morgan collection many outstanding Renaissance bronzes, most of which had formerly been in great European collections of the nineteenth century. The resulting group of sculptures is perhaps the finest collection of small bronzes in the United States and one of the finest in the world. In the Living Hall, Library, and West Gallery these bronzes are arranged with the paintings, providing an agreeable change of scale and material but sustaining the same artistic quality in examples by Riccio, Severo da Ravenna, Antonio Pollajuolo, and others.

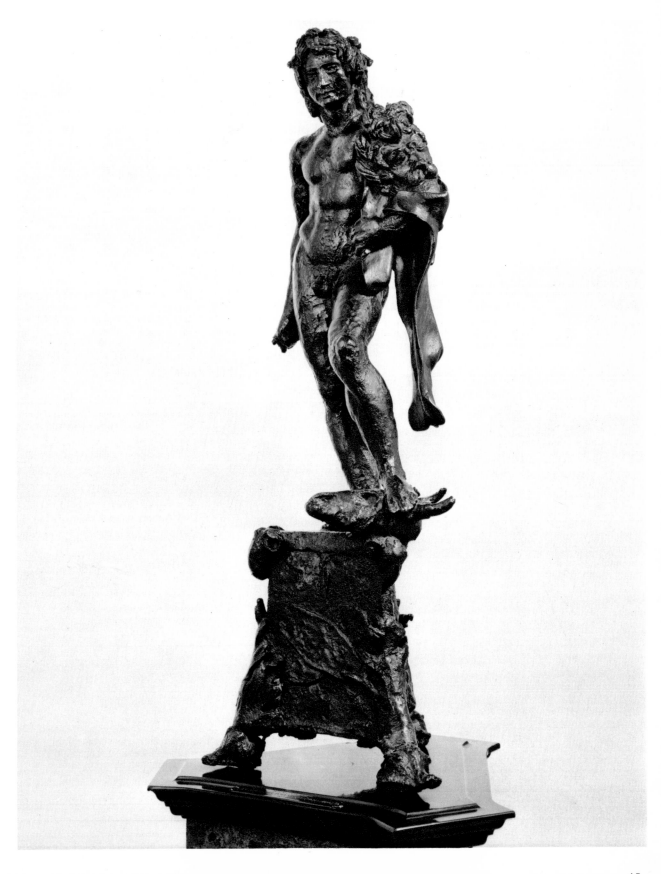

ANTONIO POLLAJUOLO (1426–1498)
HERCULES
Bronze
Height: 17⅜ in. (44.1 cm.);
Height of figure: 11¾ in. (30 cm.)

The Library

Over the fireplace in this oak-panelled room is a portrait of Henry Clay Frick by John C. Johansen. To a degree this modest collection of books may be regarded as the genesis of The Frick Art Reference Library, a research center for art history which was created by Miss Helen C. Frick. The Frick Art Reference Library, now located at 10 East Seventy-First Street, was founded in 1920 and opened in 1924.

In the Library at The Frick Collection is a concentration of English portraits and landscapes set off by a group of *famille noire* and other Chinese porcelains from the late seventeenth century, over twenty examples of Renaissance bronzes, and some English side chairs from the Queen Anne period (1702–21).

Two portraits by Reynolds of *Elizabeth, Lady Taylor* and *Selina, Lady Skipwith* provide, after the Holbeins and Titians, another revealing contrast of styles and personalities. The former is executed with a masterful precision within a rather geometric setting, while the latter is painted loosely, even impressionistically, in an informal, garden setting. Romney's portrait of the celebrated *Lady Hamilton* has the slight allegorical pretense of presenting her "as 'Nature,'" while Sir Thomas Lawrence alludes to Rubens' portrait of Susanne Fourment, known as the *Chapeau de paille,* in his 1827 portrait of *Julia, Lady Peel;* Lady Peel's husband, the eminent statesman Sir Robert Peel, had acquired Rubens' painting only four years earlier.

Constable's *Salisbury Cathedral from the Bishop's Garden* was executed in 1826 for Dr. John Fisher, the Bishop of Salisbury; his nephew, the Archdeacon John Fisher, owned Constable's *The White Horse,* which was added to The Frick Collection in 1943. Suggesting the unity of the great church with its natural setting, *Salisbury Cathedral* reflects a familiar theme of the Gothic revival. Turner's *Mortlake Terrace: Early Summer Morning* displays in contrast a more purely temporal concern with the subjective experience of the transitory effects of light.

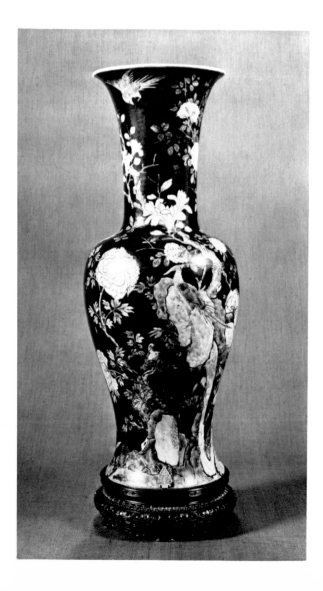

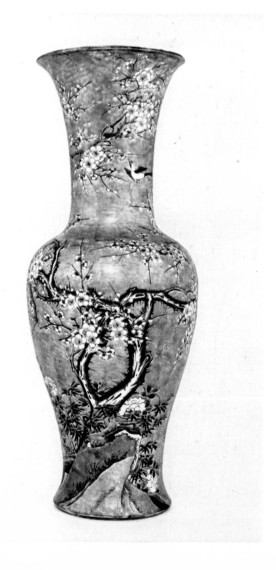

CHINESE PORCELAIN,
Reign of K'ang Hsi
"BLACK HAWTHORN" VASE
Height: 27¼ in. (69.2 cm.)

CHINESE PORCELAIN,
Reign of K'ang Hsi
VASE WITH PLUM BLOSSOMS AND BIRDS
Height: 27 in. (68.6 cm.)

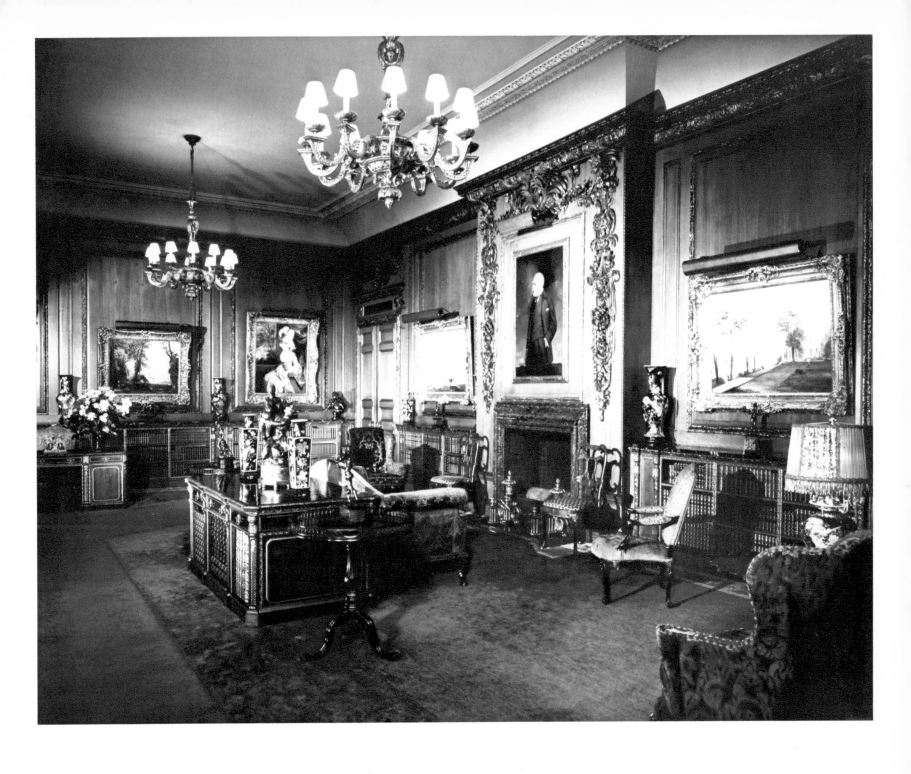

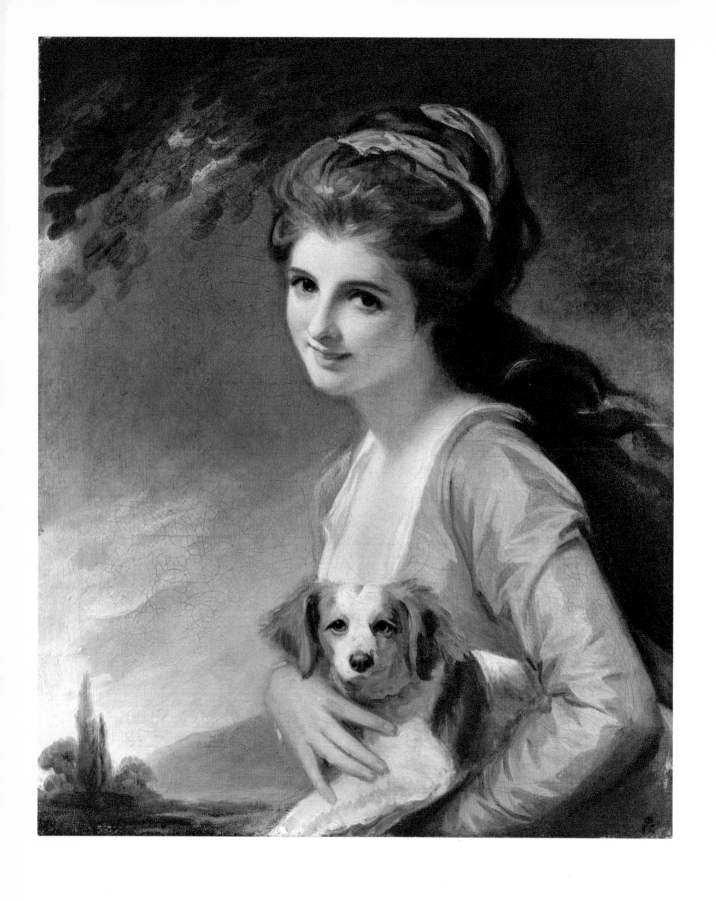

GEORGE ROMNEY (1734–1802)
LADY HAMILTON AS 'NATURE'
Oil, on canvas
29⅞ × 24¾ in. (75.8 × 62.8 cm.)

SIR THOMAS LAWRENCE (1769–1830)
JULIA, LADY PEEL
Oil, on canvas
35¾ × 27⅞ in. (90.8 × 70.8 cm.)

49

JOSEPH MALLORD WILLIAM TURNER
(1775–1851)

MORTLAKE TERRACE:
EARLY SUMMER MORNING

Oil, on canvas
36⅝ × 48½ in. (93 × 123.2 cm.)

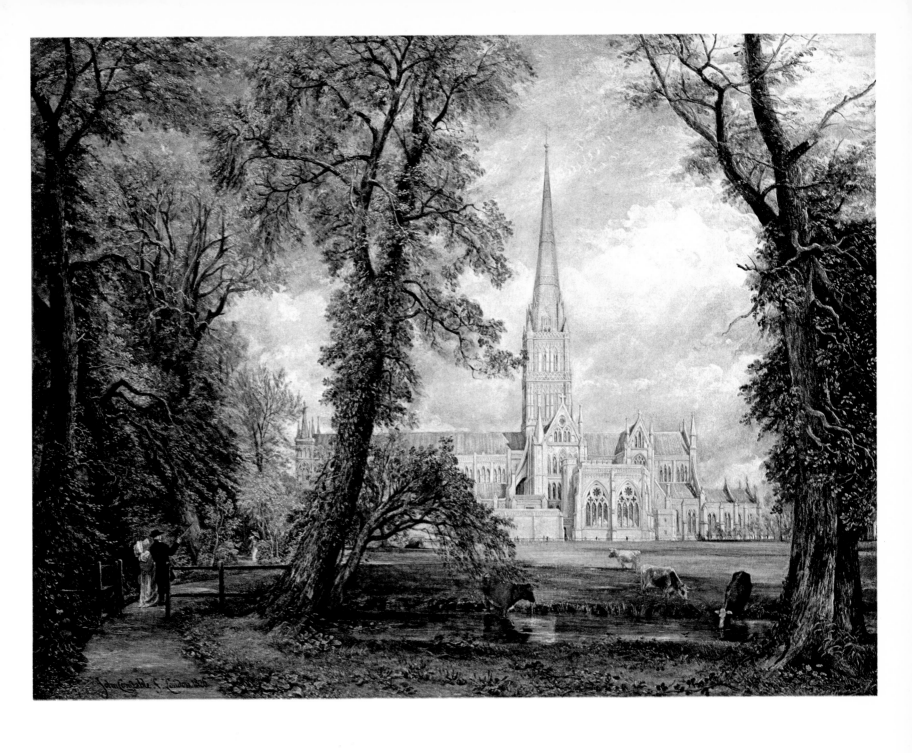

JOHN CONSTABLE (1776–1837)
SALISBURY CATHEDRAL
FROM THE BISHOP'S GARDEN
Oil, on canvas
35 × 44¼ in. (88.9 × 112.4 cm.)

Among the earliest of Mr. Frick's drawing acquisitions bequeathed to the Collection are two figure studies and an unusual chalk and wash landscape by Gainsborough, all bought in 1913. At that time two portraits by the artist were already in Mr. Frick's collection, and subsequently five more Gainsboroughs were acquired. The drawing illustrated here is believed to be a preliminary study for the portrait of *Mrs. Philip Thicknesse,* painted in Bath in 1760 and now in the Cincinnati Art Museum. In contrast to its relaxed and flowing composition, the artist's portrait of *Sarah, Lady Innes,* in a turquoise dress, painted probably in Ipswich around 1757, is somewhat stiff in a manner more closely dependent upon the artist's local predecessors.

◁ THOMAS GAINSBOROUGH (1727–1788)
STUDY FOR THE PORTRAIT
OF MRS. THICKNESSE
Pencil and black crayon, on white paper
14¹¹/₁₆ × 10½ in. (37.3 × 26.6 cm.)

THOMAS GAINSBOROUGH ▷
SARAH, LADY INNES
Oil, on canvas
40 × 28⅝ in. (101.6 × 72.7 cm.)

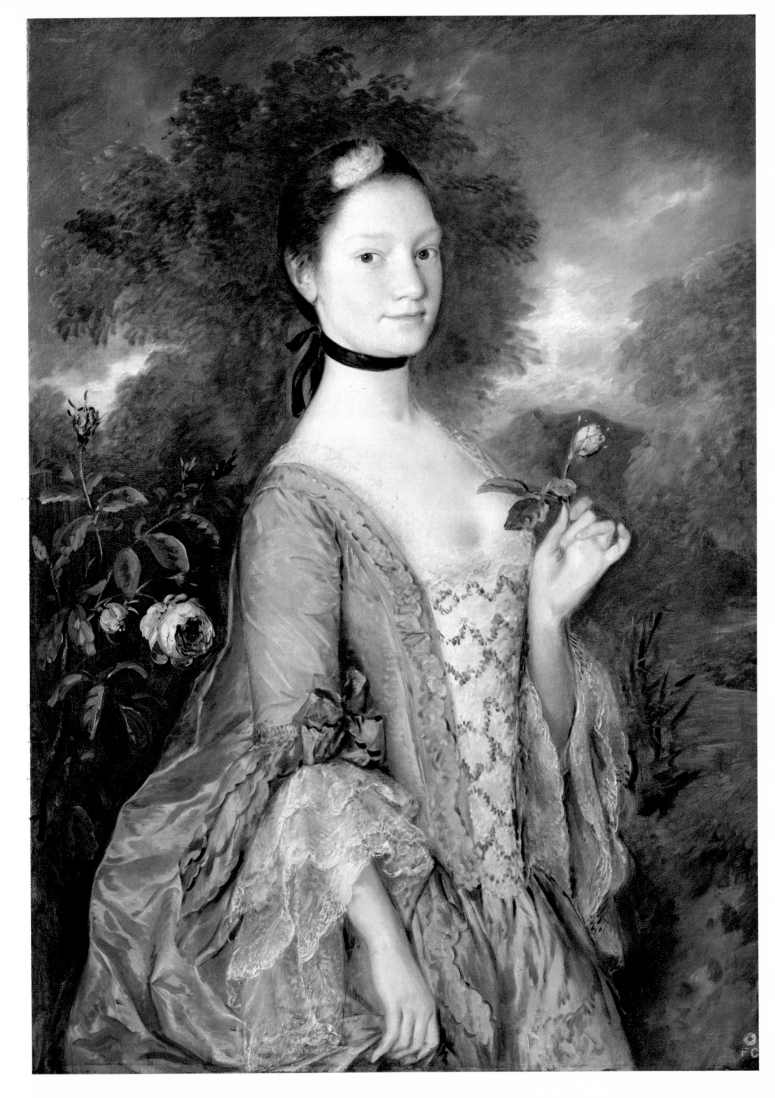

The North Hall

In assembling and exhibiting his drawings and prints, Mr. Frick followed the same broad taste he had with his paintings, acquiring works from different periods without any desire to accumulate an encyclopedic collection. Among the drawings added to this original group since his death are important works by Pisanello and Rubens, both bought in 1936 from the former Oppenheimer collection. In recent years it has been the policy of the Trustees to purchase drawings specifically related to works of art already in the Collection, such as Corot's study for *The Boatman of Mortefontaine* (p. 13) and one of Ingres' drawings executed in preparation for his portrait of the *Comtesse d'Haussonville* (p. 112). These examples of graphics often are shown in the Ante-Room and occasionally in the North Hall, in rotating exhibitions devoted to the works of a single artist—such as Rembrandt, Meryon, Blake, or Whistler—or in historical groupings, or by subject themes, such as landscapes.

The North Hall has also been used for the initial presentation of new acquisitions. Claude Lorrain's *Sermon on the Mount* (p. 105), for instance, was first exhibited there in 1960. Today the recently purchased *Madonna and Child with St. Lawrence and St. Julian,* painted by Gentile da Fabriano about 1423, hangs there, along with other works from the fifteenth century—Bastiani's *Adoration of the Magi,* Fra Filippo Lippi's *Annunciation,* and Laurana's *Bust of a Lady.*

NIKLAUS MANUEL DEUTSCH
(1484–1530)

LADY ON HORSEBACK AND A LANSQUENET

Pen and ink heightened with white, on gray-green prepared paper
12⅛ × 8⅝ in. (32.1 × 21.9 cm.)

GENTILE DA FABRIANO ▷
(active 1408–d. 1427)

MADONNA AND CHILD
WITH ST. LAWRENCE AND ST. JUL

Tempera, on panel
35¹³⁄₁₆ × 18½ in. (91 × 47 cm.)

· SC · LAVRETIVS · · SC · IVLIANVS ·

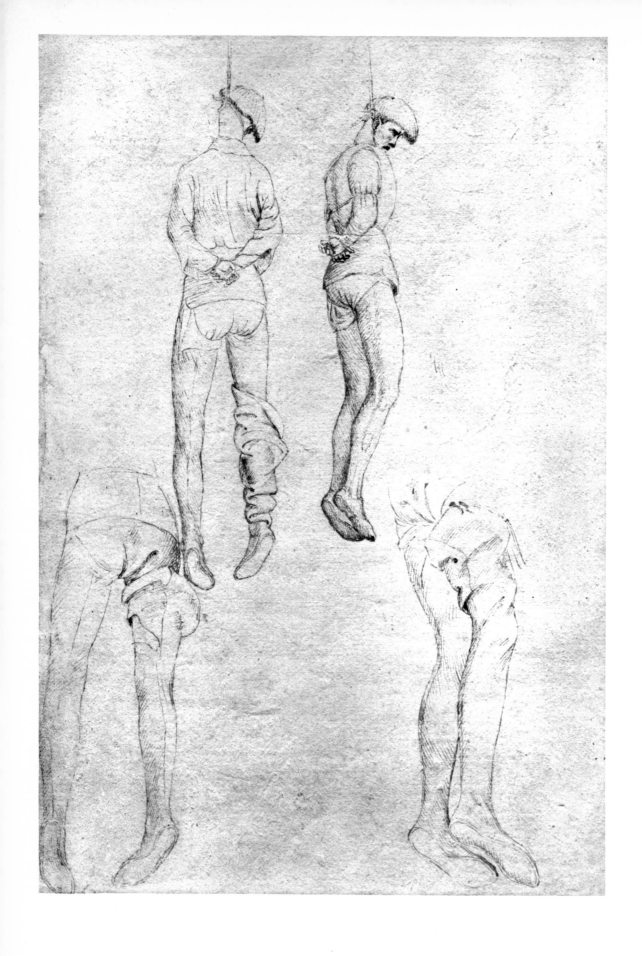

ANTONIO PISANELLO (1395–1456)
STUDIES OF MEN HANGING ON THE
GALLOWS
Brown ink, on white paper
$10\frac{3}{8} \times 7\frac{1}{16}$ in. (26.4 × 17.9 cm.)

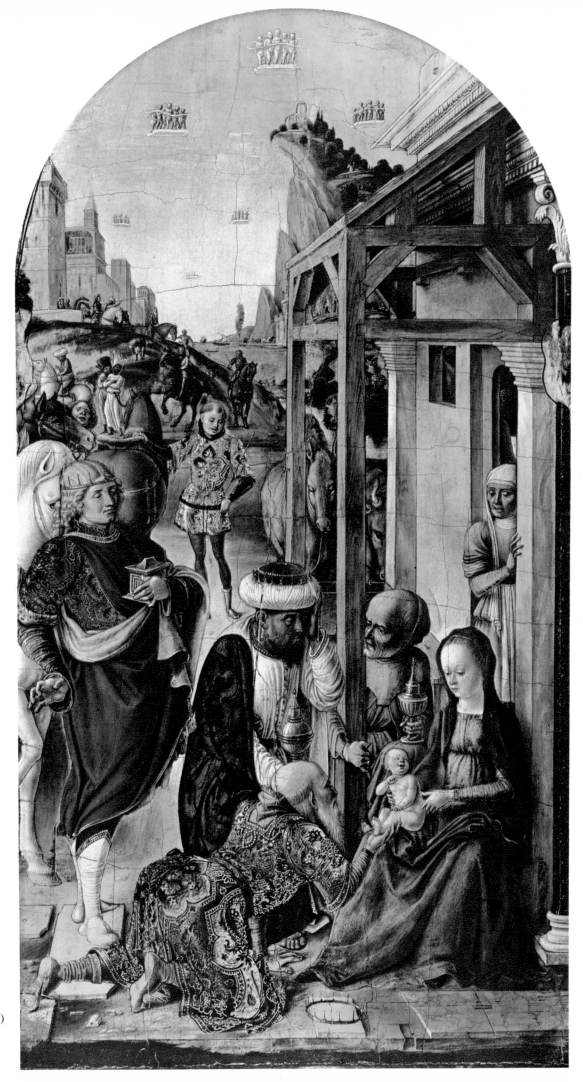

Lazzaro Bastiani (d. 1512)
ADORATION OF THE MAGI
Tempera, on poplar panel
20½ × 11 in. (52 × 28 cm.)

Rubens' *Studies of Venus* once belonged to Sir Thomas Lawrence, along with another drawing (now in the collection of Count Antoine Seilern, London) which at one time formed part of the same sheet; the two were cut apart at some unknown date. Executed around 1620, The Frick Collection drawing bears on the verso studies for the small *Last Judgment* in the Pinacothek, Munich.

The marble bust by Laurana in The Frick Collection is one of nine such portrait busts executed by this Italian sculptor. Aloof and enigmatic in expression, its subject has eluded positive identification. The extreme purity of its form is heightened by the contrast of the active mythological frieze ornamenting its base.

SIR PETER PAUL RUBENS (1577–1640)
STUDIES OF VENUS (RECTO)
Brown ink, on white paper
8 × 11 1/16 in. (20.3 × 28.1 cm.)

FRANCESCO LAURANA (C. 1430–C. 1502)
BUST OF A LADY
Marble
Height: 18 3/8 in. (46.6 cm.);
Width: 18 in. (45.8 cm.);
Depth: 9 3/8 in. (23.9 cm.)

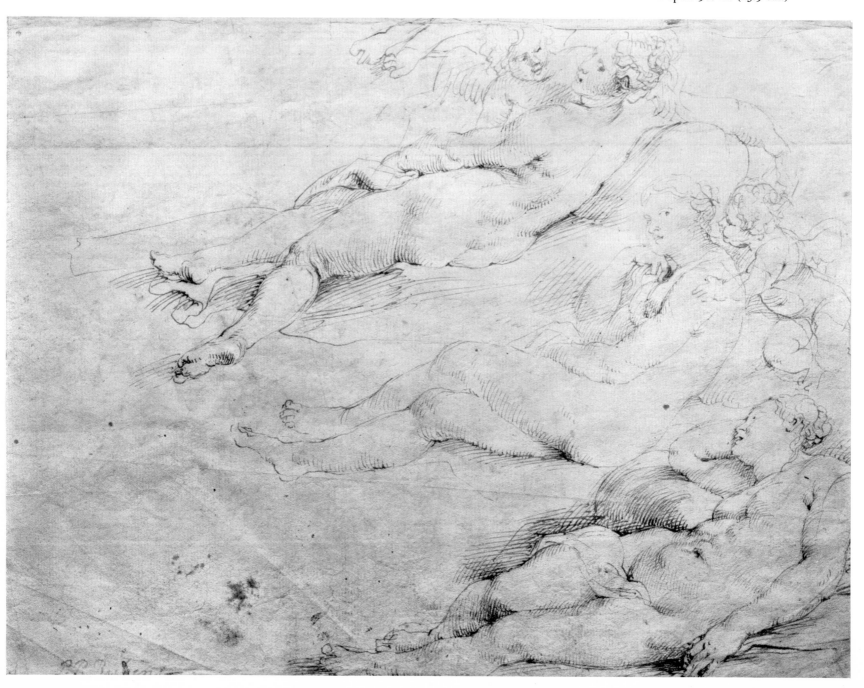

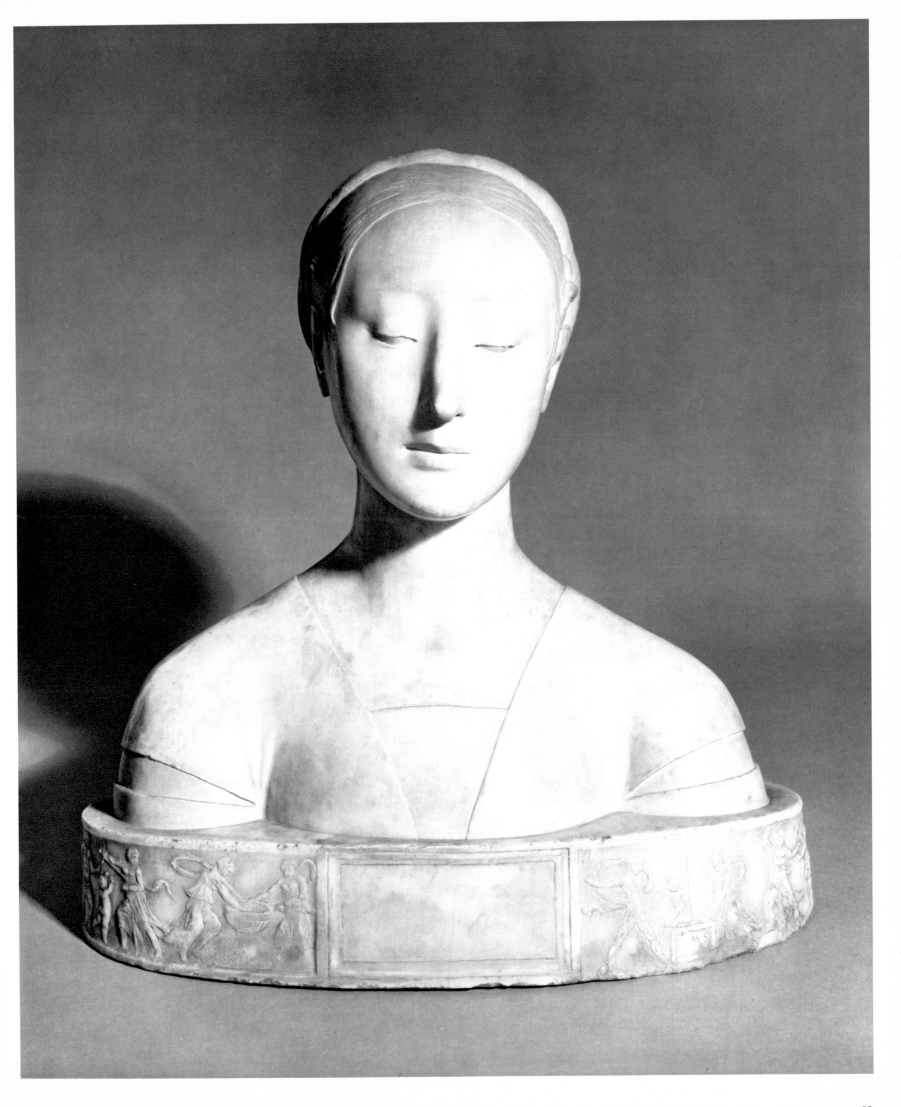

The West Gallery

The West Gallery was planned from the start as an imposing setting for a major portion of the Collection, recalling the gallery of Hertford House (home of The Wallace Collection), those of English country houses, and ultimately the royal salons of the Renaissance and Baroque periods. By 1913 Mr. Frick's collection had grown so large that it required such a picture gallery; neither of his other residences, "Clayton" in Pittsburgh and his summer home, "Eagle Rock," at Pride's Crossing, Massachusetts, had provided such space, although his temporary residence in New York at 640 Fifth Avenue had. The grand scale of the West Gallery (96 × 33 feet) has permitted a fascinating juxtaposition of works of art in the manner Mr. Frick preferred: Corot alongside Hobbema, Rembrandt confronting Velázquez, Vermeer opposite Veronese. Renaissance bronzes and furniture, as well as the subtle, abstract designs of three Isfahan carpets, further enrich the gallery. In the remodelling of the original house, the appearance of the West Gallery was affected by the addition of the large arched doorways at either end, the one at the entrance to the Enamel Room replacing a pair of doors, and that at the east end replacing a large fireplace. When van Eyck's *Virgin and Child, with Saints and Donor* (pp. 93–94) was first placed on exhibition, it was dramatically framed by this arched entrance to the Enamel Room. But following the consistent policy of rehanging paintings in the galleries, this same arch now provides an even more harmonious setting for Piero della Francesca's large painting believed to represent *St. Simon* (p. 97).

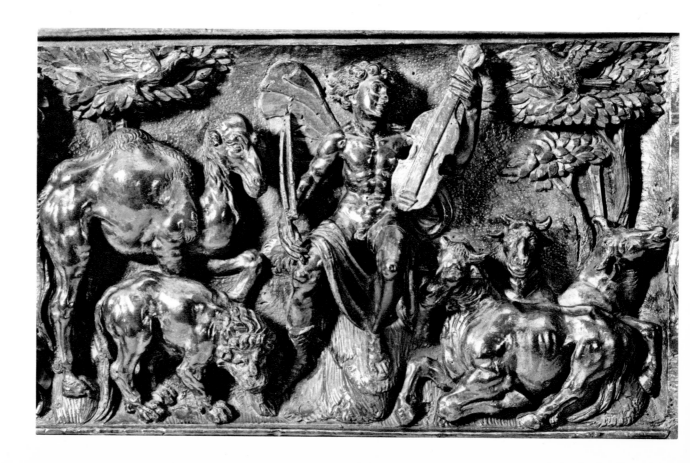

NORTHERN ITALY,
mid-sixteenth century

WALNUT COFFER (CASSONE) – DETAIL
ORPHEUS WITH BIRDS AND BEASTS

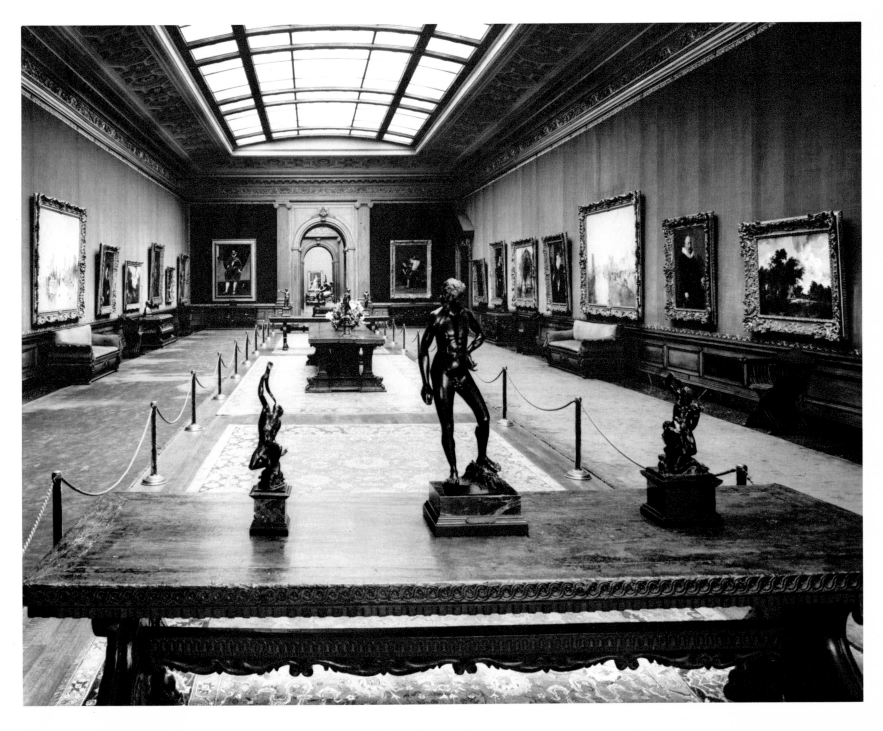

This bronze reliquary bust has been attributed to Hans Multscher—though that sculptor is otherwise known exclusively for work in wood and stone—and is probably contemporary with his altar at Sterzing (1456–58). The letter K suggests that the bust represents St. Catherine of Siena. On the top of the head there is a rectangular opening for relics.

One of the few religious subjects in painting acquired by Mr. Frick, Gerard David's *Deposition* is a very early example of a Northern European painting executed in oil on canvas. In its somber but rich and varied coloring the painting was one of the first to exploit fully the dramatic possibilities of the new oil medium.

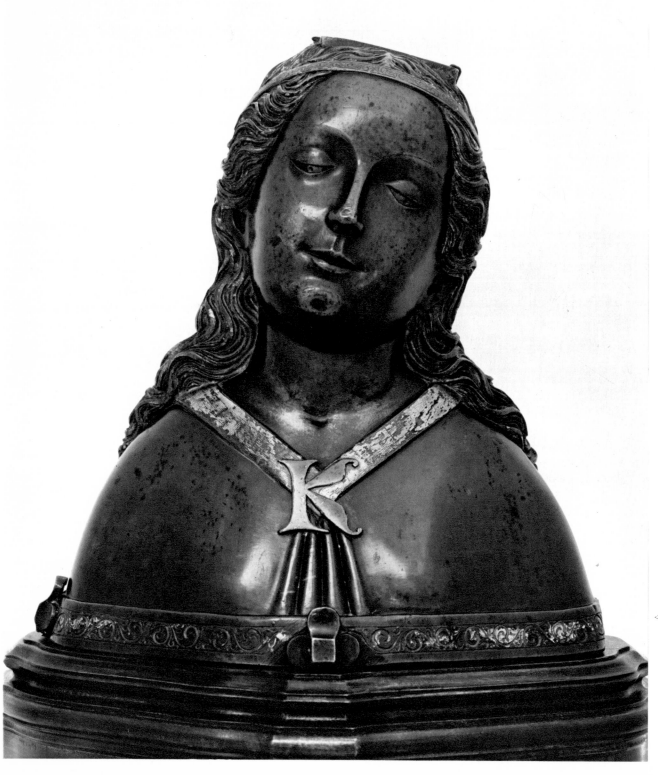

◁ HANS MULTSCHER (c. 1400–1467)
RELIQUARY BUST OF A FEMALE SAINT
Bronze
Height: 12⅝ in. (32 cm.)

GERARD DAVID (active 1484–d. 1523) ▷
THE DEPOSITION
Oil, on linen, mounted on mahogany panel
56⅛ × 44¼ in. (142.5 × 112.4 cm.)

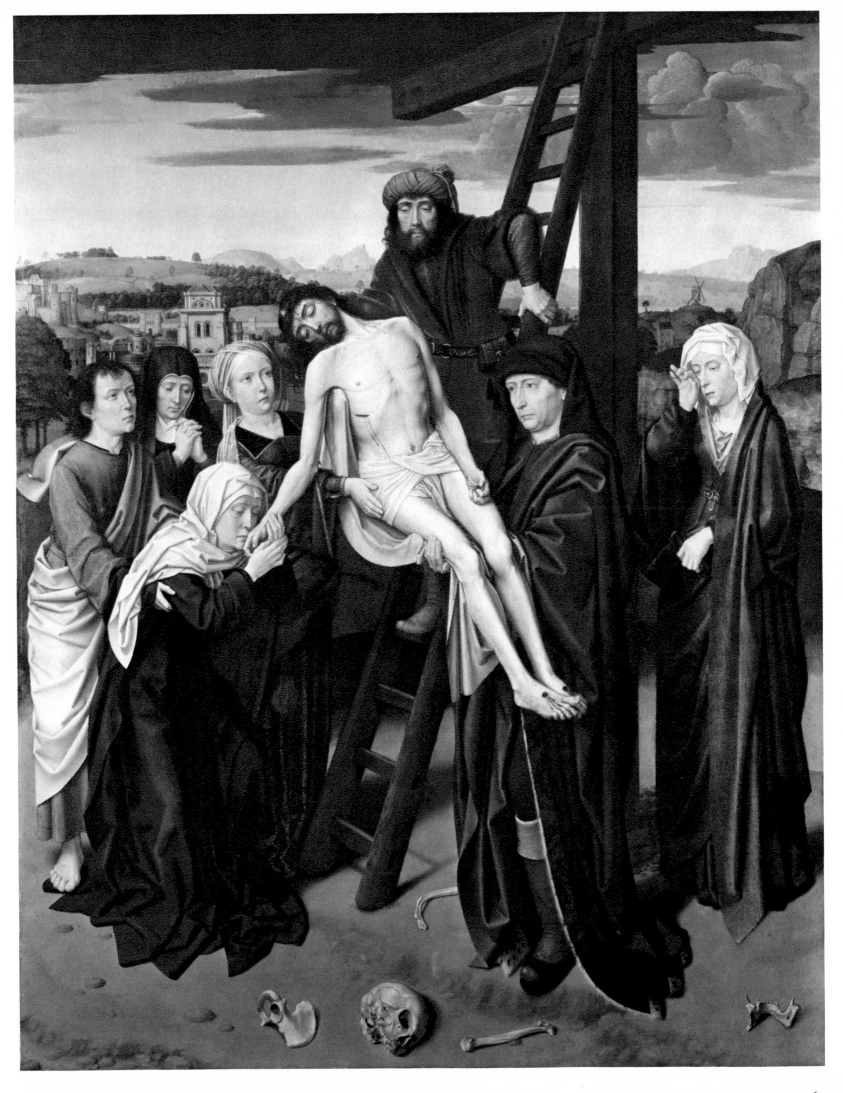

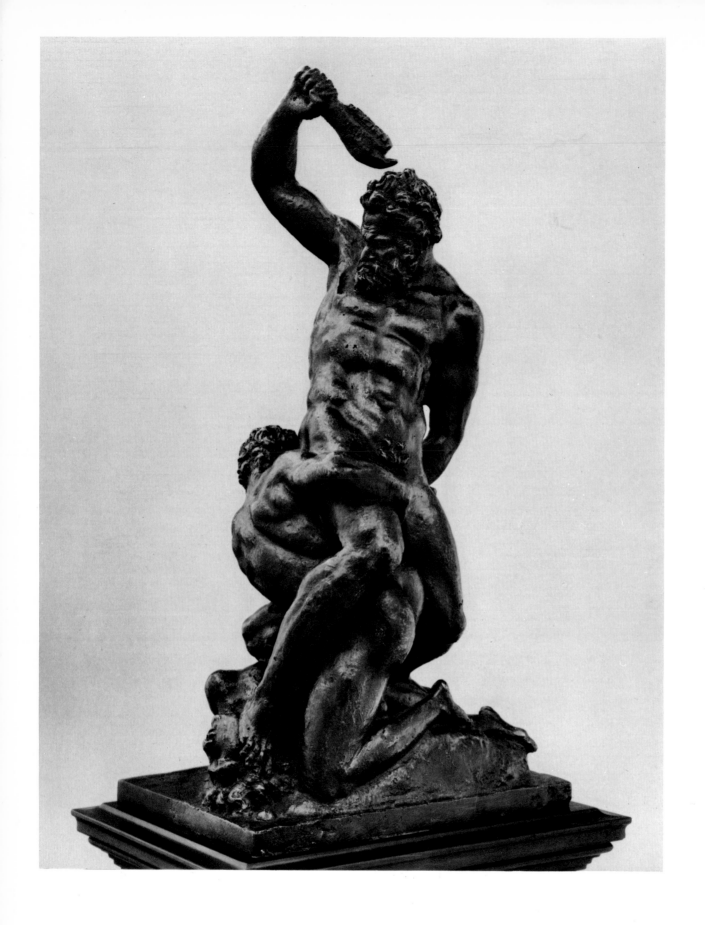

After MICHELANGELO (1475–1564)
SAMSON AND TWO PHILISTINES
Bronze
Height: 14½ in. (36.7 cm.)

AGNOLO BRONZINO (1503–1572)
LODOVICO CAPPONI
Oil, on poplar panel
45⅞ × 33¾ in. (116.5 × 85.7 cm.)

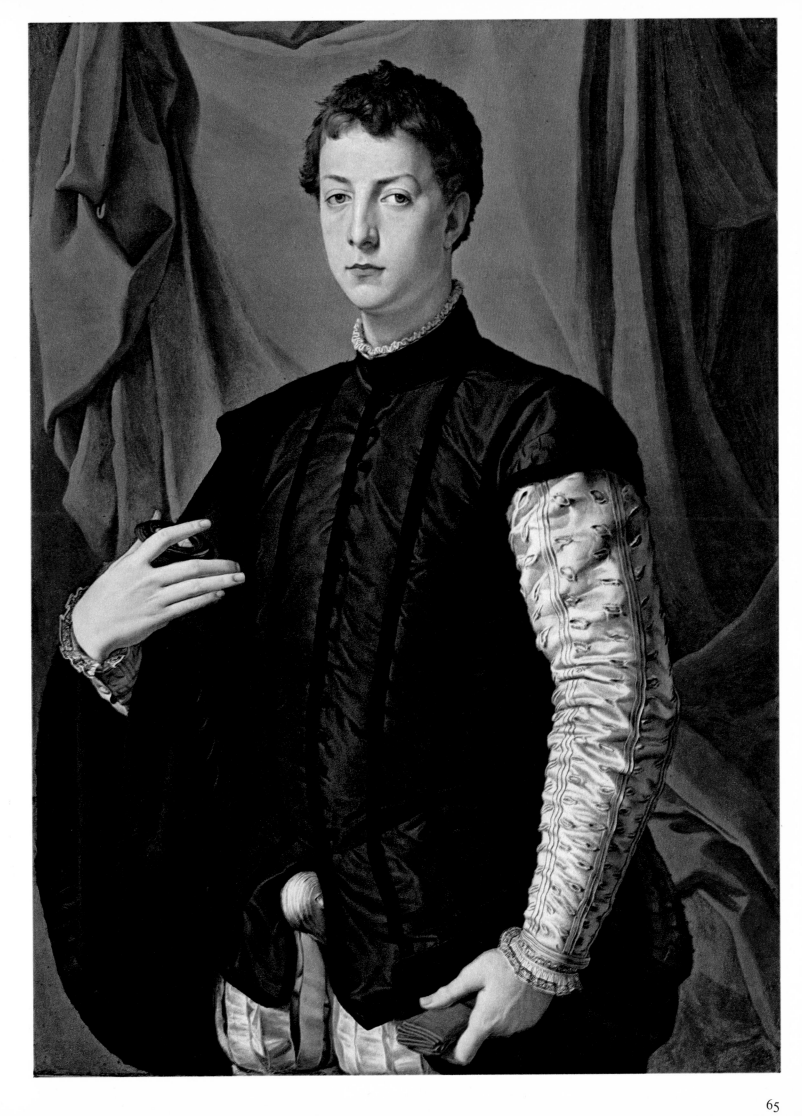

In the *Allegory of Virtue and Vice* Veronese has treated the popular Renaissance theme of Hercules at the crossroads. The hero, wearing the garb of a sixteenth-century courtier, resists the seductive appeals of Vice and advances towards Virtue, who reaches out to him in a protective gesture. It is her arduous but ultimately more rewarding alternative which Hercules chooses, rather than the easy life of pleasure offered by Vice.

It is not certain that this painting and its equally majestic companion, the *Allegory of Wisdom and Strength,* were executed as pendants, although they have always been together in such distinguished collections as those of the Emperor Rudolph II, Queen Christina of Sweden, and the Duc d'Orléans. In *Wisdom and Strength* the artist depicts the triumph of celestial values over worldly things, with Hercules, powerful but somnolent, looking down at a cluster of jeweled crowns and objects symbolic of earthly power, while the figure of Wisdom looks upward to heavenly light. At their feet a putto grasps a scepter.

◁ PAOLO CALIARI (IL VERONESE)
(c. 1528–1588)
ALLEGORY OF WISDOM AND STRENGTH –
DETAIL

PAOLO CALIARI (IL VERONESE) ▷
ALLEGORY OF VIRTUE AND VICE
(THE CHOICE OF HERCULES)
Oil, on canvas
86¼ × 66¾ in. (219 × 169.5 cm.)

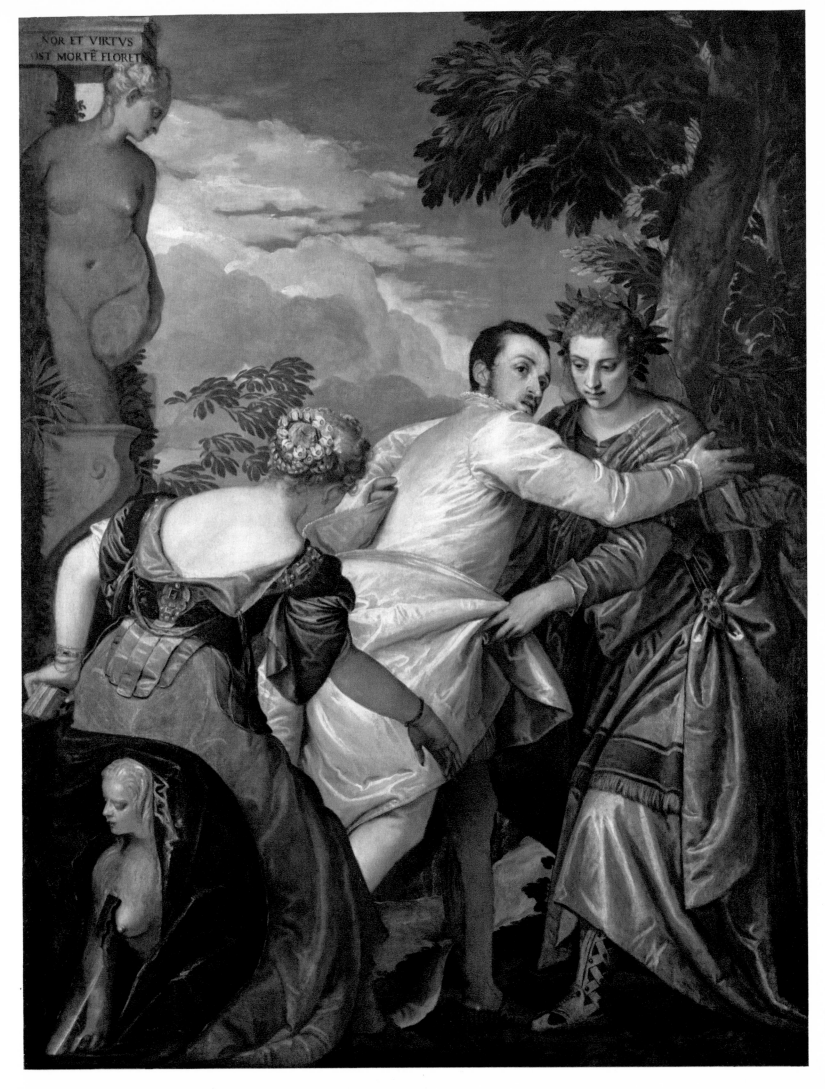

In addition to the three portraits by Goya in the Collection, there are two other remarkable portraits by Spanish artists: El Greco's *Vincenzo Anastagi,* a high officer in the Knights of Malta painted by El Greco during his last years in Italy, and *King Philip IV of Spain,* painted by Velázquez in 1644 at Fraga, where the king was with his forces after winning an important victory against the French. One of Velázquez' noblest portraits, it was executed in a dilapidated building, where a room was specially strewn with rushes for the three occasions that Philip posed for the artist.

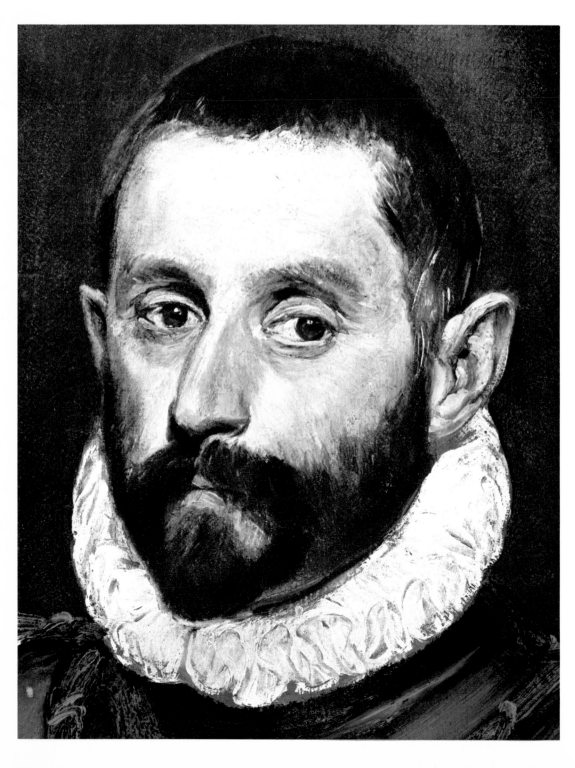

DOMENIKOS THEOTOKOPOULOS
(EL GRECO) (1541–1614)
VINCENZO ANASTAGI – DETAIL

DIEGO RODRÍGUEZ DE SILVA ▷
Y VELÁZQUEZ (1599–1660)
KING PHILIP IV OF SPAIN
Oil, on canvas
51 ⅛ × 39 ⅛ in. (129.8 × 99.4 cm.)

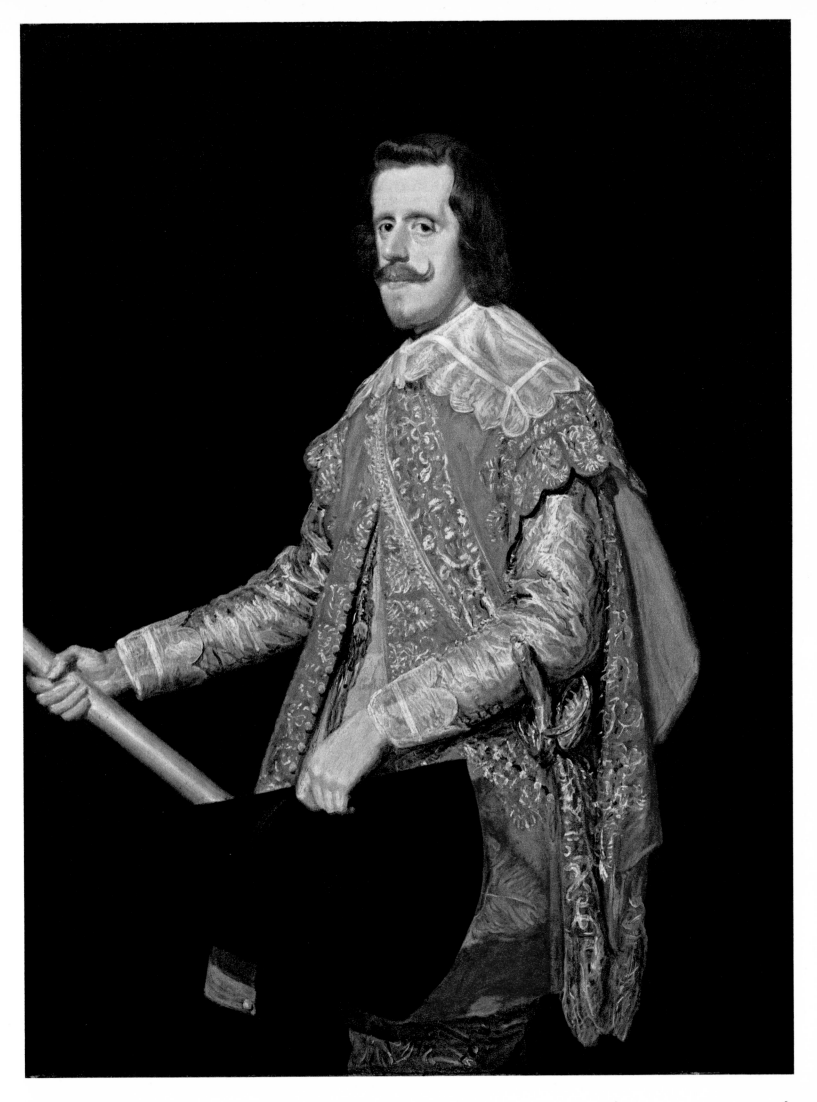

The Frick Collection includes eight portraits by Van Dyck. From the artist's Antwerp period of the early 1620s date the companion pictures of *Frans Snyders* and his wife, *Margareta.* The detail of flowers in the portrait of the artist's wife may be an allusion to the artistic specialty of her husband, who was a celebrated painter of still life, as well as of animals and hunting scenes. Later examples of Van Dyck range in date from the artist's Genoese period, such as the portrait of *Paola Adorno, Marchesa di Brignole Sale,* to portraits painted in England, such as the large-scale family group of *James, Seventh Earl of Derby, His Lady and Child,* dating from around 1633.

It is revealing of Mr. Frick's tastes that of the Northern European Baroque painters, he chose to acquire a large series of important paintings by Van Dyck and nothing by the artist's master, Rubens. The formal restraint of Van Dyck's work and the psychological nuances of his portraits must have corresponded to Mr. Frick's aesthetic preferences over the more spectacular, sensual effects favored by many of this artist's Flemish contemporaries, such as Rubens and Jordaens.

SIR ANTHONY VAN DYCK (1599–1641)
MARGARETA SNYDERS – DETAIL

SIR ANTHONY VAN DYCK
FRANS SNYDERS
Oil, on canvas
56⅛ × 41½ in. (142.5 × 105.4 cm.)

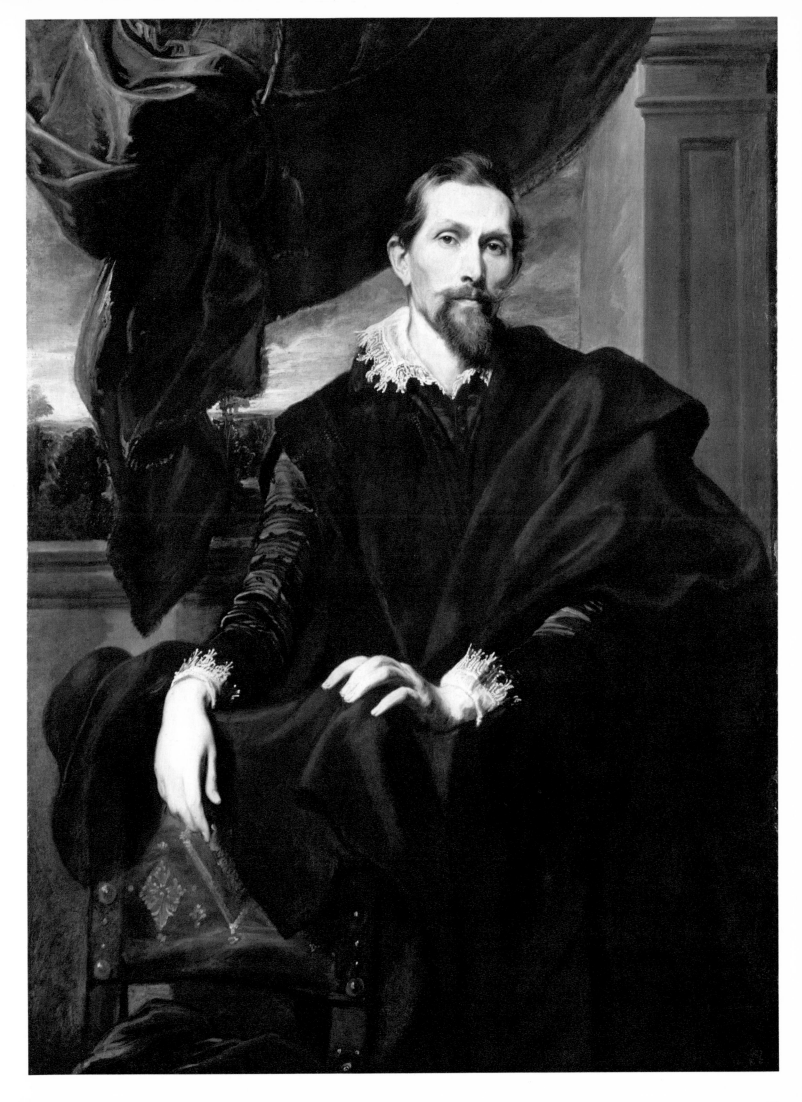

Attracted as he was both by the portrait genre and by Dutch seventeenth-century painting, Mr. Frick not surprisingly acquired portraits by Frans Hals—four in all. Unidentified, the subjects include a variety of ages and physical types. Unquestionably the *Portrait of a Man* presents Hals' technique at its most spectacular. This portrait's simple but dazzling tonal contrasts overshadow the more restrained, robust honesty of the earlier *Portrait of a Woman*.

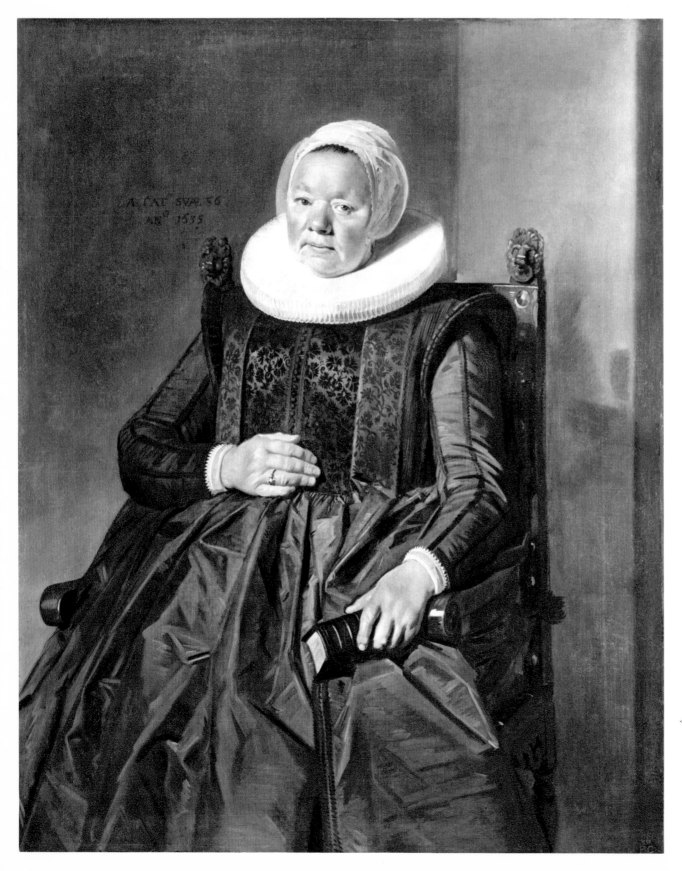

◁ FRANS HALS (1581/85–1666)

PORTRAIT OF A WOMAN

Oil, on canvas

45⅞ × 36¾ in. (116.5 × 93.3 cm.)

FRANS HALS ▷

PORTRAIT OF A MAN

Oil, on canvas

44½ × 32¼ in. (113 × 81.9 cm.)

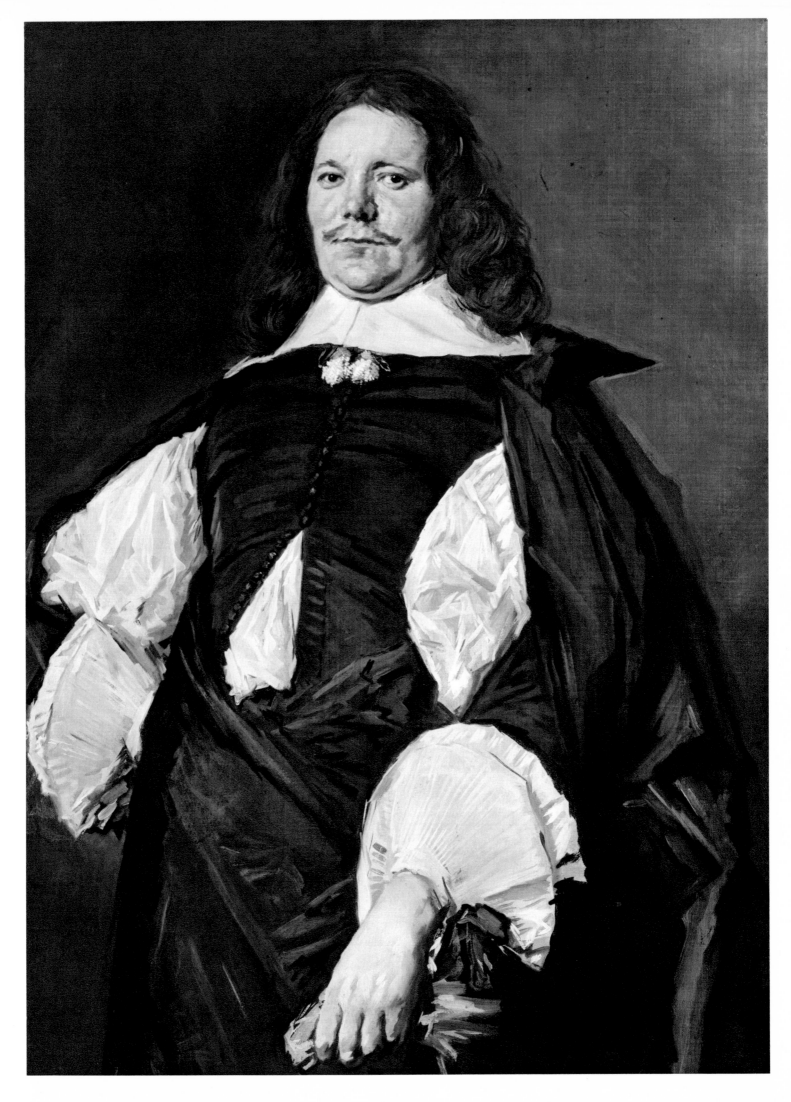

Mr. Frick, who repeatedly expressed his enthusiasm for the art of Rembrandt, assembled a choice collection of that artist's work, not merely in paintings alone but in drawings and prints as well. The *Portrait of a Young Artist* was purchased in 1899, followed by the *Self-Portrait* in 1906 and *The Polish Rider* in 1910. In 1943, The Frick Collection acquired the 1631 portrait of *Nicolaes Ruts,* perhaps the young Rembrandt's earliest commission in Amsterdam.

The Polish Rider, which is one of Rembrandt's most evocative conceptions, still eludes a precise iconographical interpretation—an unknown youth riding at twilight through an ominous landscape, with towers, cliffs, and a dimly discernible pond at the edge of which glows a fire.

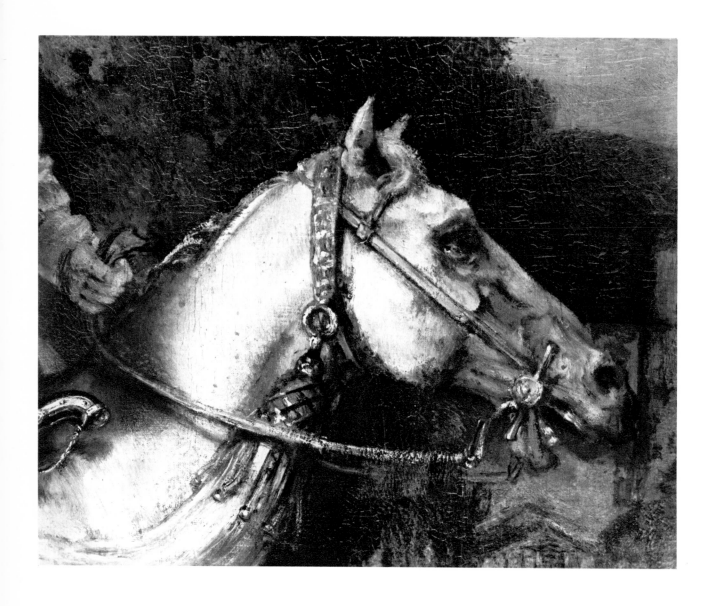

REMBRANDT HARMENSZ. VAN RIJN
(1606–1669)

THE POLISH RIDER – DETAIL

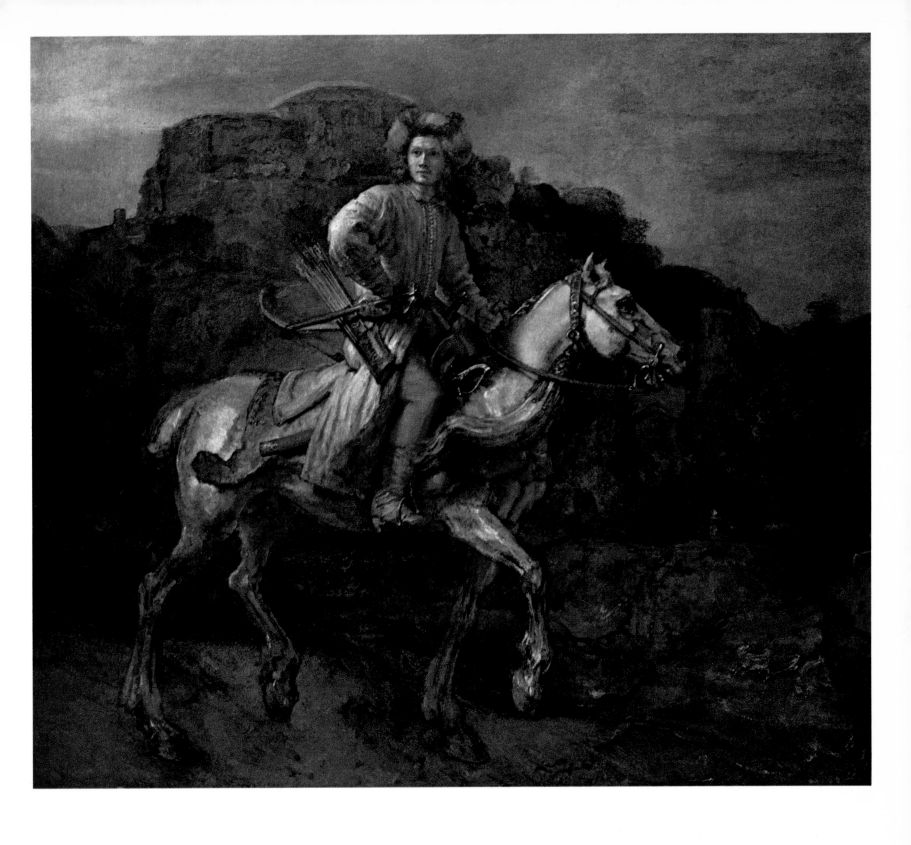

REMBRANDT HARMENSZ. VAN RIJN
THE POLISH RIDER
Oil, on canvas
46 × 53⅛ in. (116.8 × 134.9 cm.)

Certainly the greatest painting by Rembrandt which Mr. Frick was able to acquire was the so-called Ilchester *Self-Portrait,* signed and dated 1658. The artist, poor and plagued with personal problems, represents himself—in a poignant and perhaps ironic contrast—in the rich garb and enthroned posture of an oriental potentate.

As the first of his drawing acquisitions which still remain in the Collection, Mr. Frick purchased three Rembrandts: *Farm Buildings and Tree, Landscape with Cottage and Trees,* and *Isaac Blessing Jacob.* Subsequently, eleven etchings by Rembrandt were acquired, including superb examples of *The Three Trees, The Hundred-Guilder Print, The Three Crosses,* and the print which was on Mr. Frick's desk at the time of his death—*Christ Presented to the People.*

◁ Rembrandt Harmensz. van Rijn
LANDSCAPE WITH COTTAGE AND TREES
Reed pen and bistre and gray
washes, on tan paper
6 5/16 × 9 1/16 in. (16 × 23 cm.)

Rembrandt Harmensz. van Rijn ▷
SELF-PORTRAIT
Oil, on canvas
52 5/8 × 40 7/8 in. (133.7 × 103.8 cm.)

The important group of eleven Dutch seventeenth-century landscapes in The Frick Collection testifies to the founder's lasting enthusiasm for these rich, placid vistas which provided a counterpoint to the numerous portraits in his collection. The landscapes present a wide range of subject and style, from Cuyp's Arcadian *Cows and a Herdsman by a River* and his luminous harbor scene *Dordrecht: Sunrise* to Jacob van Ruisdael's topographical rendering of the *Quay at Amsterdam,* as well as characteristic works by Hobbema and Salomon van Ruysdael. Possibly Mr. Frick's early interest in the Barbizon School led him back to one of the primary sources of that group of landscapists. Certainly his Troyon, *Pasture in Normandy,* which he acquired in 1899, was inspired by Cuyp.

JACOB VAN RUISDAEL (1628/29–1682)

LANDSCAPE WITH A FOOTBRIDGE

Oil, on canvas

38¾ × 62⅝ in. (98.4 × 159.1 cm.)

JOHANNES VERMEER (1632–1675) ▷

MISTRESS AND MAID

Oil, on canvas

35½ × 31 in. (92 × 78.7 cm.)

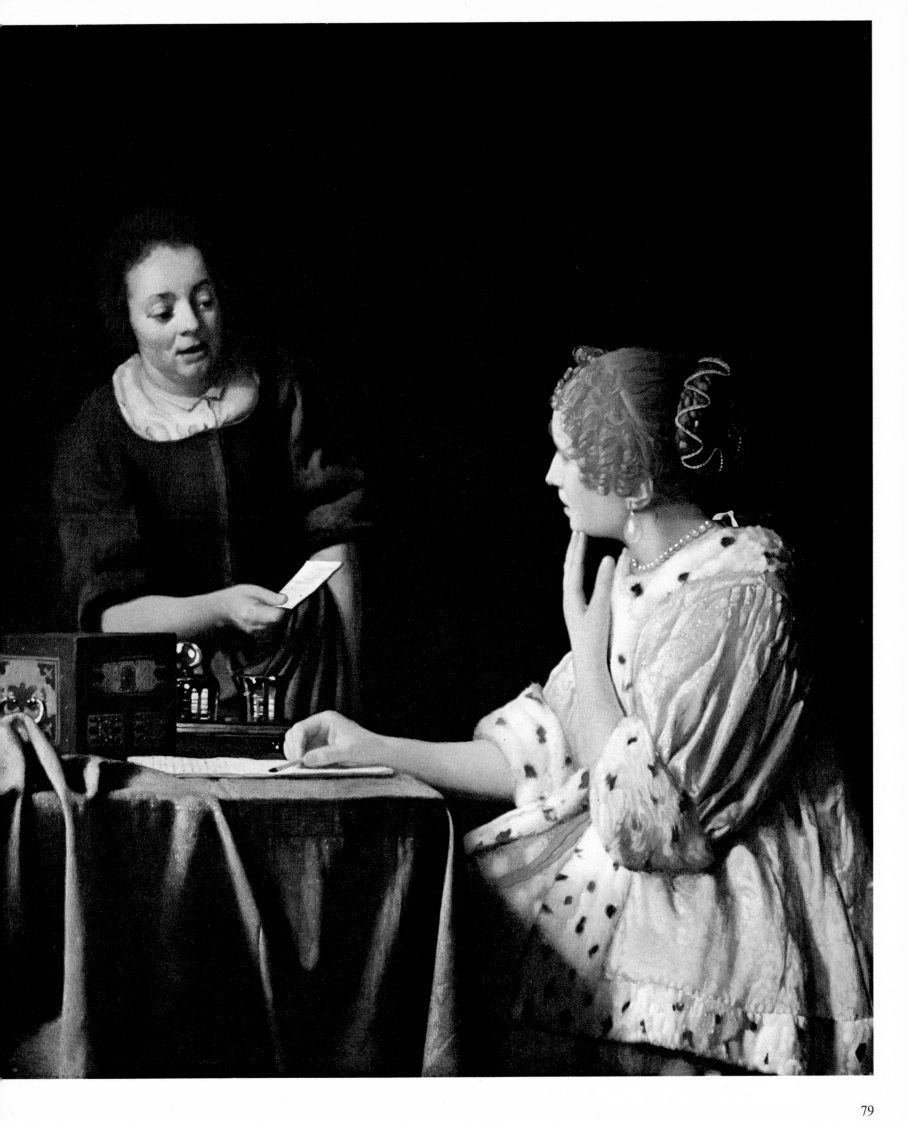

In 1915 and 1916 Mr. Frick assembled a choice group of French and Italian Renaissance furniture, a field of collecting which had appealed to such nineteenth-century collectors as the Comte de Pourtalès, Prince Demidoff, and Lord Hertford. The French pieces, with their mixture of late Gothic mannerisms and Renaissance allusions to antiquity, provide an especially harmonious setting for the Limoges enamels displayed in the Enamel Room. In the West Gallery three monumental Italian sixteenth-century tables and four pairs of *cassoni* have been placed symmetrically within the large expanse of the room.

TUSCANY, mid-sixteenth century
WALNUT TABLE
Height: 32½ in. (82.5 cm.);
Length: 185½ in. (470 cm.);
Width: 45½ in. (115.4 cm.)

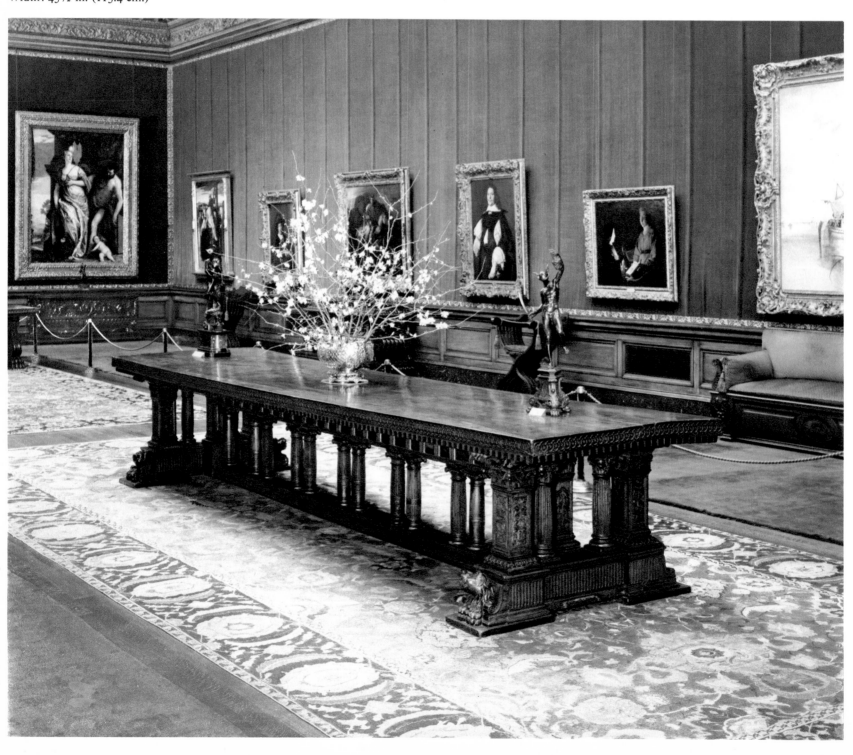

GEORGES DE LA TOUR (1593–1652)
THE EDUCATION OF THE VIRGIN
Oil, on canvas
33 × 39½ in. (83.8 × 100.4 cm.)

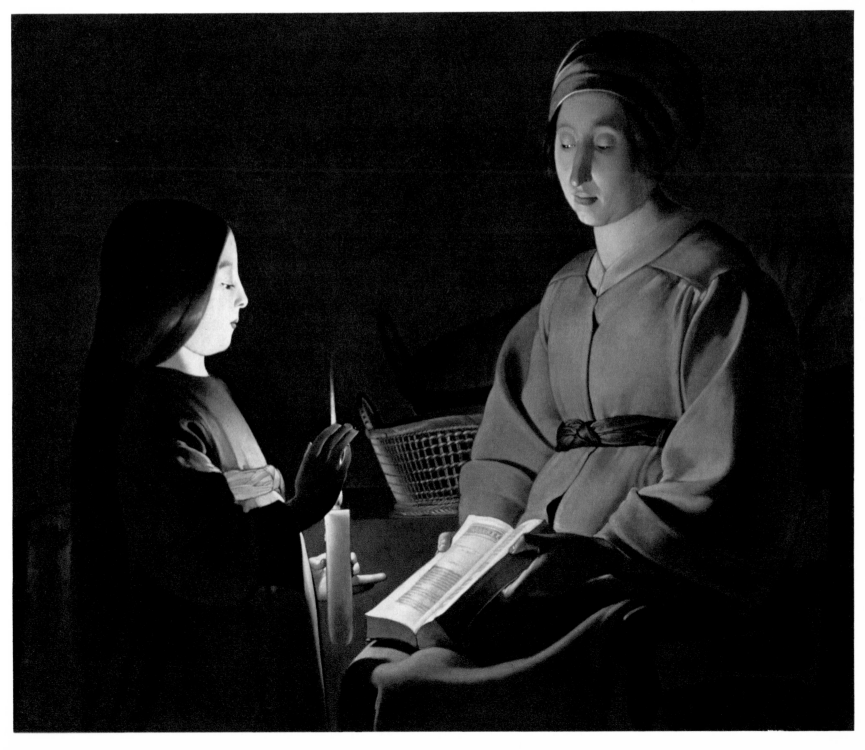

Three of the four paintings by Goya in The Frick Collection were acquired in 1914: the romantic *Portrait of an Officer,* the nearly monochromatic *Portrait of Doña María Martínez de Puga,* dated 1824, and *The Forge,* which was executed about 1815–20. In addition there is the portrait of *Don Pedro, Duque de Osuna* (p. 110), strikingly casual in pose and with a sparkling tone characteristic of Goya's earlier work around 1795. The small drawing of *Anglers Under a Rock,* which anticipates the powerful drama of *The Forge,* dates from 1799 and is thus contemporary with the *Desastres de la Guerra;* the page on which it was executed, with writing at the top, apparently came from an old record book.

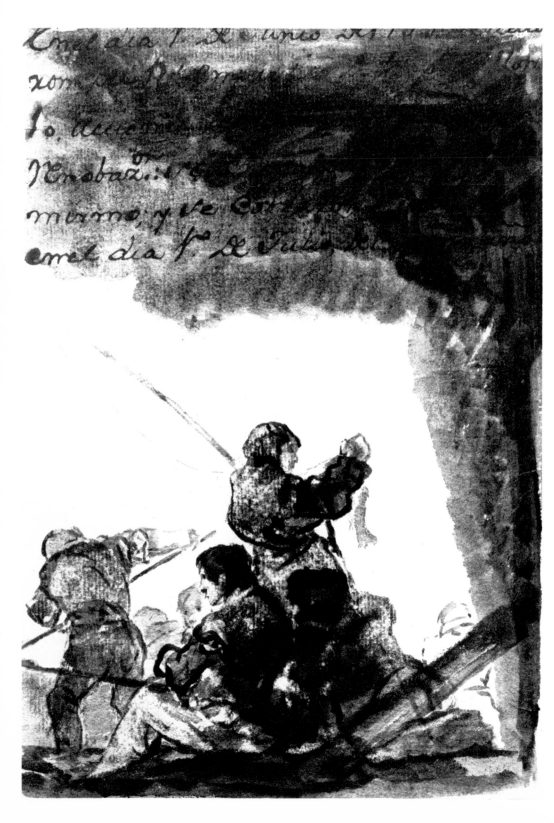

FRANCISCO DE GOYA Y LUCIENTES
(1746–1828)

ANGLERS UNDER A ROCK
Sepia wash, on white paper
7¾ × 5⅜ in. (19.7 × 13.7 cm.)

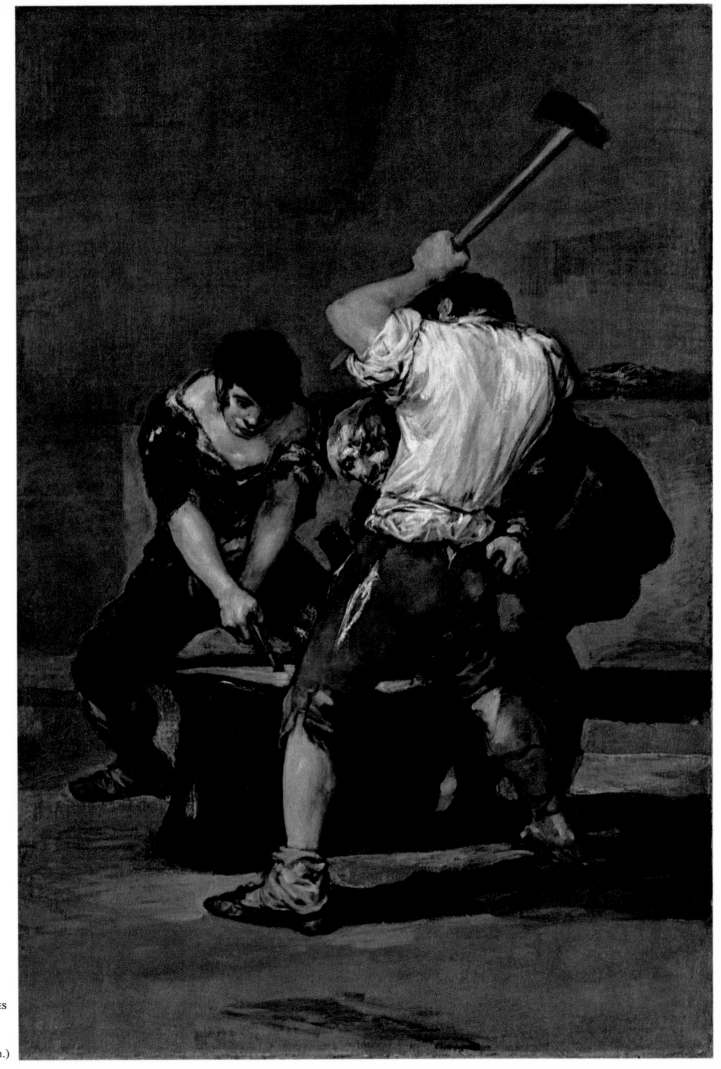

In 1914 Mr. Frick acquired the two large paintings by Turner depicting the ports of Cologne and Dieppe. Previously he had purchased the 1833 *Antwerp: Van Goyen Looking Out for a Subject,* one of the artist's art-historical themes; the turbulent *Fishing Boats Entering Calais Harbor* of about 1803, visible in the view of the South Hall (p. 10); and the placid *Mortlake Terrace: Early Summer Morning* of 1826 (p. 50), which combines a Canaletto-like expanse with Turner's typically diaphanous effects of soft morning light.

 The Harbor of Dieppe and *Cologne: The Arrival of a Packet-Boat: Evening* are two of three large exhibition pieces Turner painted representing northern Continental ports. The earliest, *Dort* or *Dordrecht,* was exhibited in 1818, the later two in 1825 and 1826 respectively. The port theme and the primary role of light in the paintings must have been intended deliberately to recall Claude Lorrain's views of harbors with a setting or rising sun.

◁ JOSEPH MALLORD WILLIAM TURNER
(1775–1851)

COLOGNE: THE ARRIVAL OF A PACKET-
BOAT: EVENING

Oil, and possibly watercolor, on canvas
66⅜ × 88¼ in. (168.6 × 224.1 cm.)

JOSEPH MALLORD WILLIAM TURNER ▷

THE HARBOR OF DIEPPE – DETAIL

The Enamel Room

From the largest room in the Collection, the West Gallery, the visitor enters the smallest—the Enamel Room, which is somewhat reminiscent of a *schatzkammer*. It houses a remarkable collection of Limoges sixteenth- and seventeenth-century enamels. The rich panelling and intimate scale of the room also make it a pleasant setting for a group of small paintings and bronzes. With two exceptions, all of Mr. Frick's enamels were acquired in 1916, most of them from the collection of the late J. Pierpont Morgan. An exceptional and varied group, they constitute one of the finest collections of enamels in the United States.

LÉONARD LIMOSIN (c. 1505–1577)
PORTRAIT OF A MAN
Limoges Enamel
$5\,^{1}/_{16} \times 4\,^{5}/_{16}$ in. (12.9 × 11 cm.)

This allegorical composition symbolizes the zealous leadership of the Catholic party against the Huguenots. Antoinette de Bourbon, Duchesse de Guise, depicted with other members of the House of Guise, rides in a golden chariot over the recumbent bodies of Protestant heretics. These latter figures were originally labelled with inscriptions in gold which have since worn off; however most of them can be identified, such as Jan Hus, Théodore de Bèze, an Adamite, representing a sect aspiring to a primitive Adam-like state of nudity, Arius, an Anabaptist, and Jean Calvin.

LÉONARD LIMOSIN
TRIUMPH OF THE FAITH
Limoges Enamel
7 9/16 × 9 7/8 in. (19.2 × 25.1 cm.)

ATELIER OF JEAN PÉNICAUD II
(c. 1510–1576)
THE FAMILY OF ST. ANNE
Limoges Enamel
11¾ × 7½, 3⅛ in. (29.3 × 19.1, 8 cm.)

MARTIAL REYMOND
(second half of the sixteenth century)
CERES SEARCHING FOR HER DAUGHTER
Limoges Enamel
14⅛ × 10⁹⁄₁₆ in. (35.8 × 26.8 cm.)

RICCIO (1460/75 (?)–1532)

LAMP

Bronze
Height: 6⅝ in. (16.9 cm.)

DUCCIO DI BUONINSEGNA
(c. 1255–1319)
THE TEMPTATION OF CHRIST
ON THE MOUNTAIN
Tempera, on poplar panel
17 × 18⅛ in. (43.2 × 46 cm.)

91

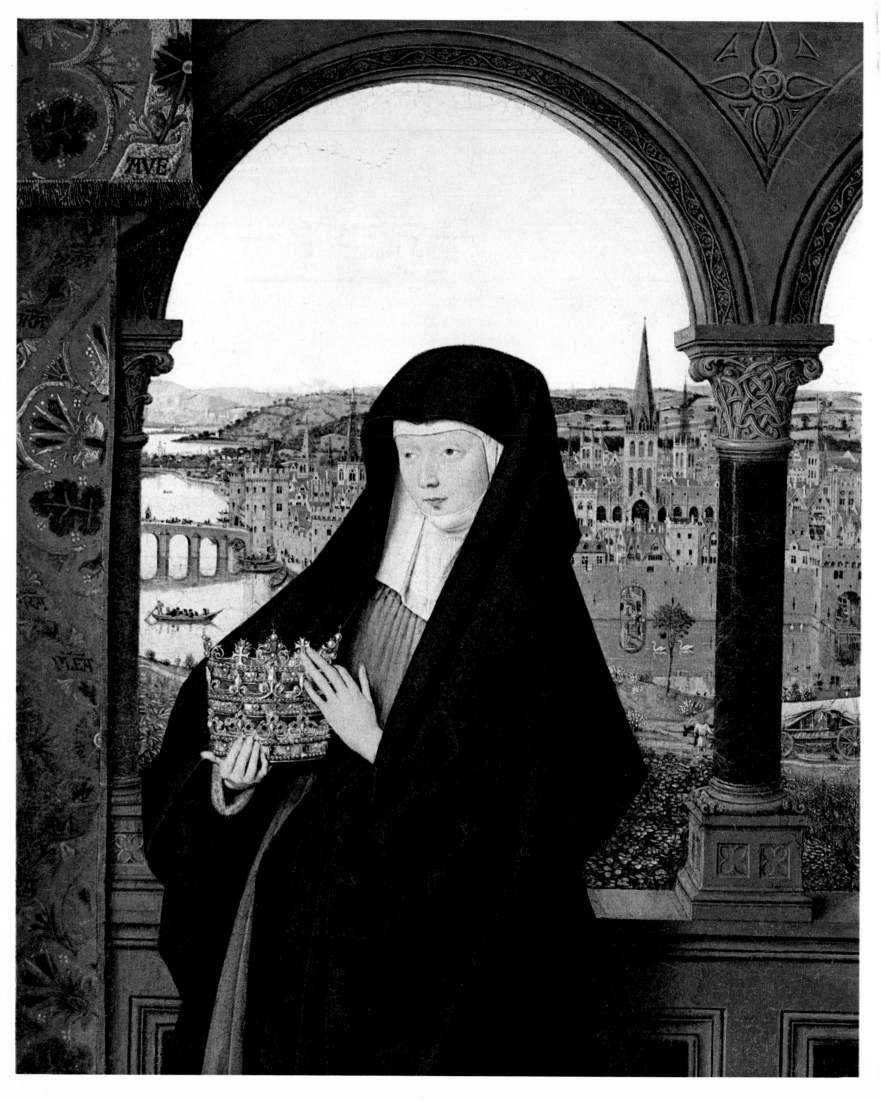

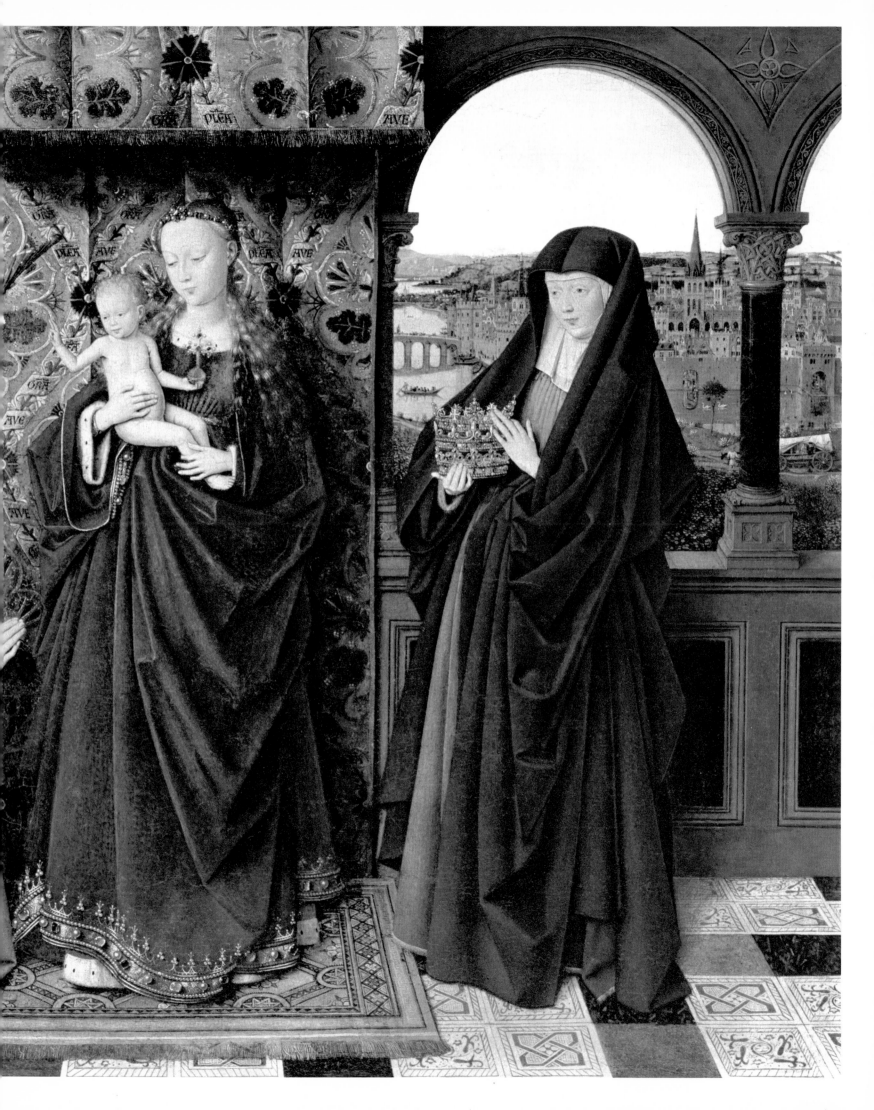

To the left of the Virgin stands St. Barbara with a tower behind her, symbolic of the imprisonment forced upon her by her father. St. Elizabeth of Hungary, identified by her rich crown, is at the right. In the foreground kneels the donor, Jan Vos, Prior of the Carthusian Charterhouse of Genadedal near Bruges, who commissioned the work. The detailed background landscape recalls the view in Jan van Eyck's *Madonna of the Chancellor Rolin* (Louvre).

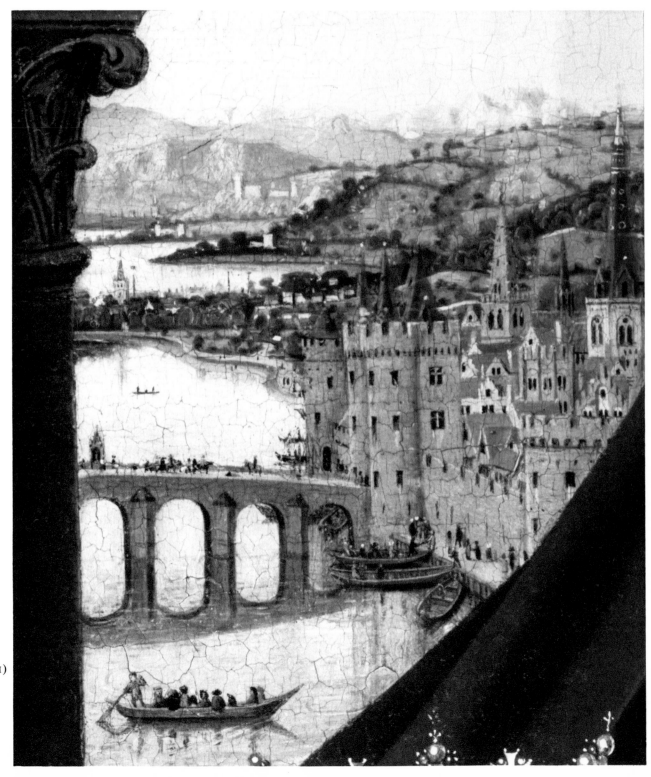

◁ JAN VAN EYCK (active 1422–1441)
VIRGIN AND CHILD, WITH SAINTS
AND DONOR – DETAIL

JAN VAN EYCK ▷
VIRGIN AND CHILD, WITH SAINTS
AND DONOR – DETAIL

In 1936 The Frick Collection acquired Piero della Francesca's painting thought to represent *St. Simon the Apostle,* and in 1950 it purchased the small panels of an *Augustinian Monk* and an *Augustinian Nun.* All three may have come originally from the same S. Agostino altarpiece commissioned from the artist in 1454. Three additional wing panels are known—*St. Michael the Archangel* (National Gallery, London), *St. Augustine* (Museu Nacional de Arte Antiga, Lisbon), and *St. Nicholas of Tolentino* (Museo Poldi-Pezzoli, Milan)—but the central portion, perhaps a Coronation of the Virgin, is lost.

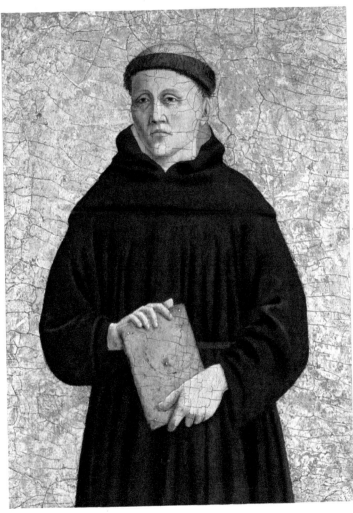

WORKSHOP OF PIERO DELLA FRANCESCA

AUGUSTINIAN NUN

Tempera, on poplar panel
15¼ × 11 in. (38.7 × 27.9 cm.)

WORKSHOP OF PIERO DELLA FRANCESCA

AUGUSTINIAN MONK

Tempera, on poplar panel
15¾ × 11⅛ in. (40 × 28.2 cm.)

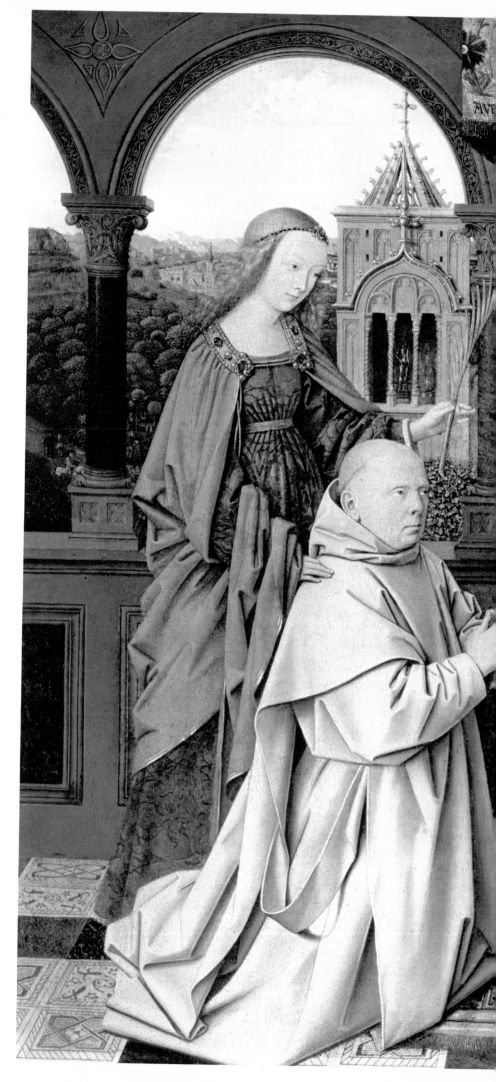

JAN VAN EYCK

VIRGIN AND CHILD, WITH SAINTS
AND DONOR

Oil, on panel

18⅝ × 24⅛ in. (47.3 × 61.3 cm.)

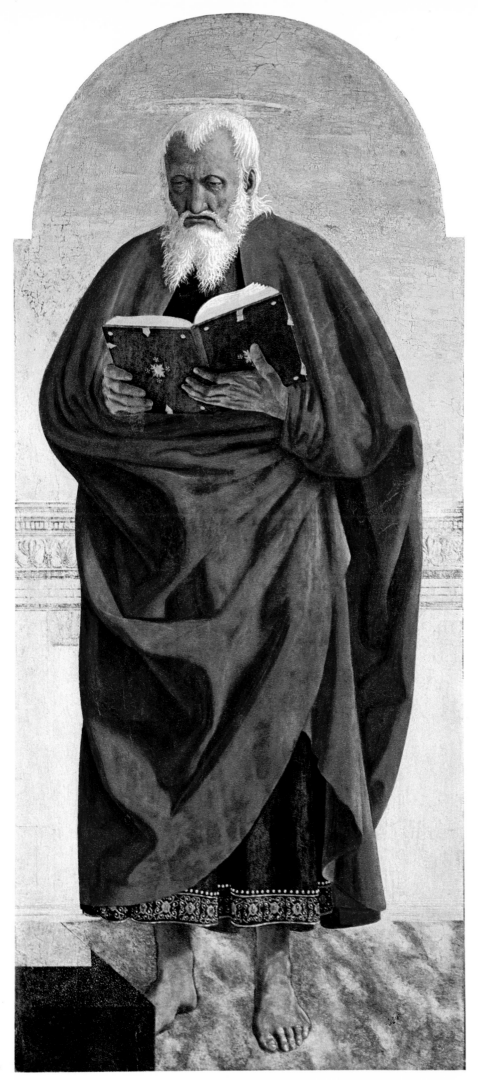

PIERO DELLA FRANCESCA
(1410/20–1492)
ST. SIMON THE APOSTLE (?)
Tempera, on poplar panel
52¾ × 24½ in. (134 × 62.2 cm.)

The Oval Room

The Oval Room, the first of the group of rooms added to the Collection in the 1931–35 remodelling, provides an imposing setting for Houdon's life-size terracotta *Diana the Huntress*. This sculpture is a version of a marble figure executed for the Duke of Saxe-Gotha but acquired instead by Catherine the Great (now in the Museu Gulbenkian, Lisbon). Mr. Frick had apparently contemplated the construction of such an oval gallery for the display of his sculptures; the Houdon piece alone recalls that intention.

Within the symmetrical disposition of the Oval Room, four full-length portraits by Van Dyck and Gainsborough confront each other, in a clear demonstration of how closely the English artist emulated his predecessor's grand style in portraiture, even to the point of depicting *The Hon. Frances Duncombe* in seventeenth-century dress associated with Van Dyck.

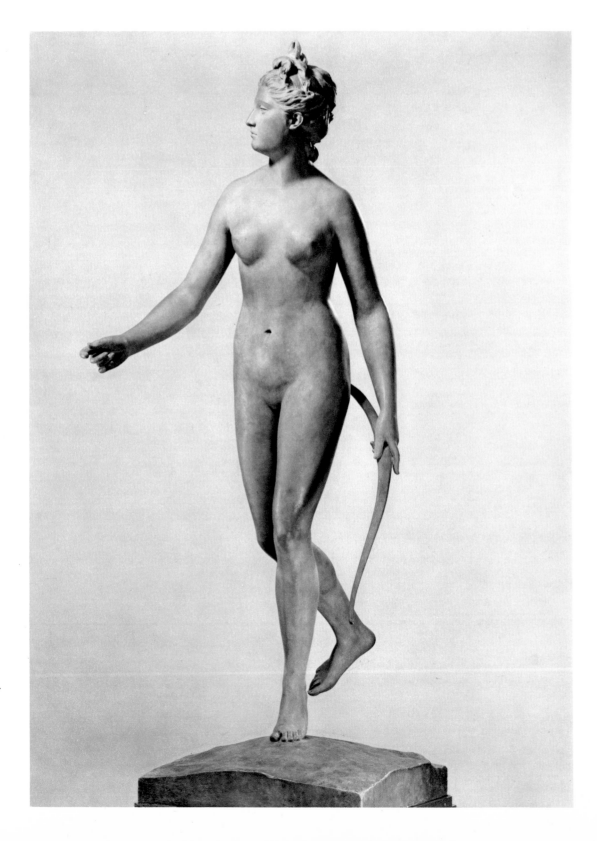

JEAN-ANTOINE HOUDON (1741–1828) ▷

DIANA THE HUNTRESS

Terracotta
Height: 75½ in. (191.8 cm.);
Height of figure: 68⅛ in. (173 cm.)

JEAN-ANTOINE HOUDON ▷▷

DIANA THE HUNTRESS – DETAIL

SIR ANTHONY VAN DYCK (1599–1641)
ANNE, COUNTESS OF CLANBRASSIL
Oil, on canvas
83½ × 50¼ in. (212.1 × 127.6 cm.)

THOMAS GAINSBOROUGH (1727–1788)
THE HON. FRANCES DUNCOMBE
Oil, on canvas
92¼ × 16⅛ in. (234.3 × 155.2 cm.)

The East Gallery

This gallery, with the adjoining Lecture Room, was built on the site of the original Frick Art Reference Library; it has been decorated in a style harmonious with the older part of the building. Like the other galleries, it contains a rich variety of works of art, from the grand classical style of Claude Lorrain's *Sermon on the Mount* and the more humble landscape manner of Claude's Dutch contemporaries, Cuyp and Ruisdael, to the rococo agitation of Tiepolo's *Perseus and Andromeda*—echoed in the Sèvres porcelain objects in the room—and to the more bourgeois manner of Greuze and Chardin. Examples of portraits from the nineteenth century include forthright images by Goya and David, as well as the elegant women depicted by Ingres and Whistler as vehicles for their elaborate formal designs. Two select French Impressionist works frequently exhibited in this gallery are Manet's *Bullfight* and Degas' *Rehearsal*. The furniture includes a set of eight armchairs covered in Beauvais tapestry after designs by Boucher and Oudry, two chests of drawers by Carel, and a commode with shelves, attributed to Riesener.

AELBERT CUYP (1620–1691)

DORDRECHT: SUNRISE

Oil, on canvas

40⅛ × 63⅜ in. (102 × 161 cm.)

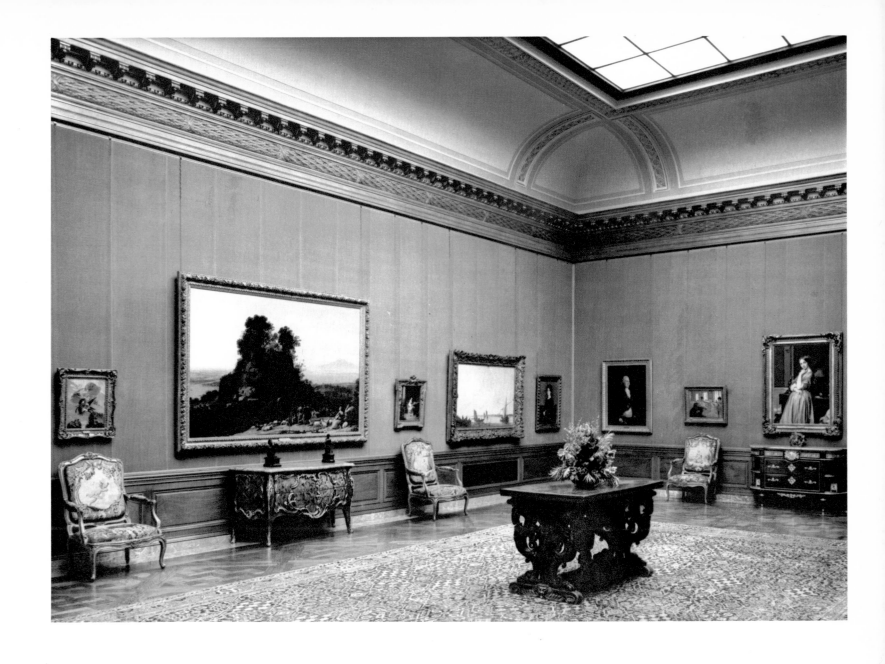

CAREL (flourished 1740–1760)

CHEST OF DRAWERS (COMMODE)

Tulipwood and kingwood, with gilt-
bronze mounts
Height: 34⅝ in. (88 cm.);
Length: 57 in. (144.8 cm.);
Depth: 27 in. (68.6 cm.)

GIOVANNI BATTISTA TIEPOLO ▷
(1696–1770)

PERSEUS AND ANDROMEDA

Oil, on paper affixed to canvas
20⅜ × 16 in. (51.8 × 40.6 cm.)

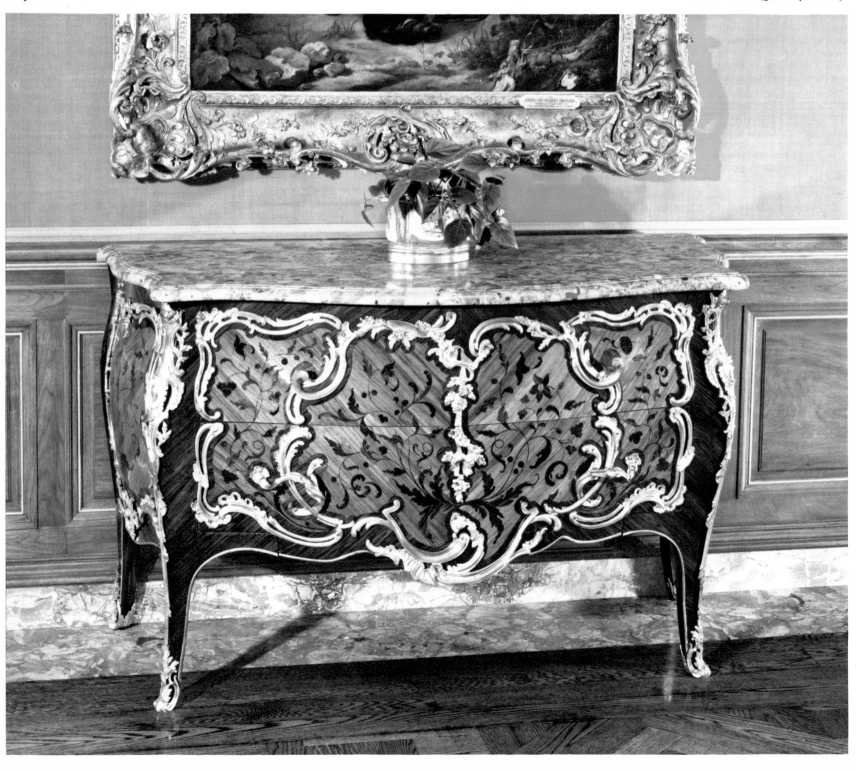

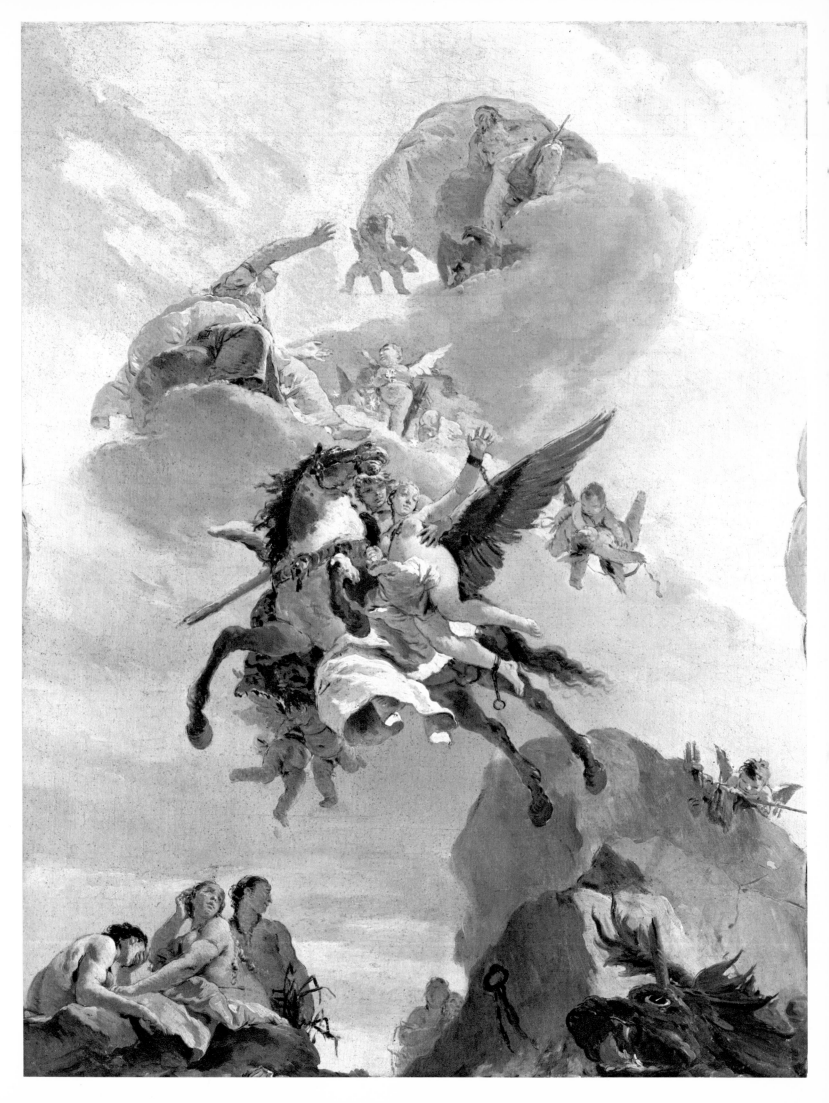

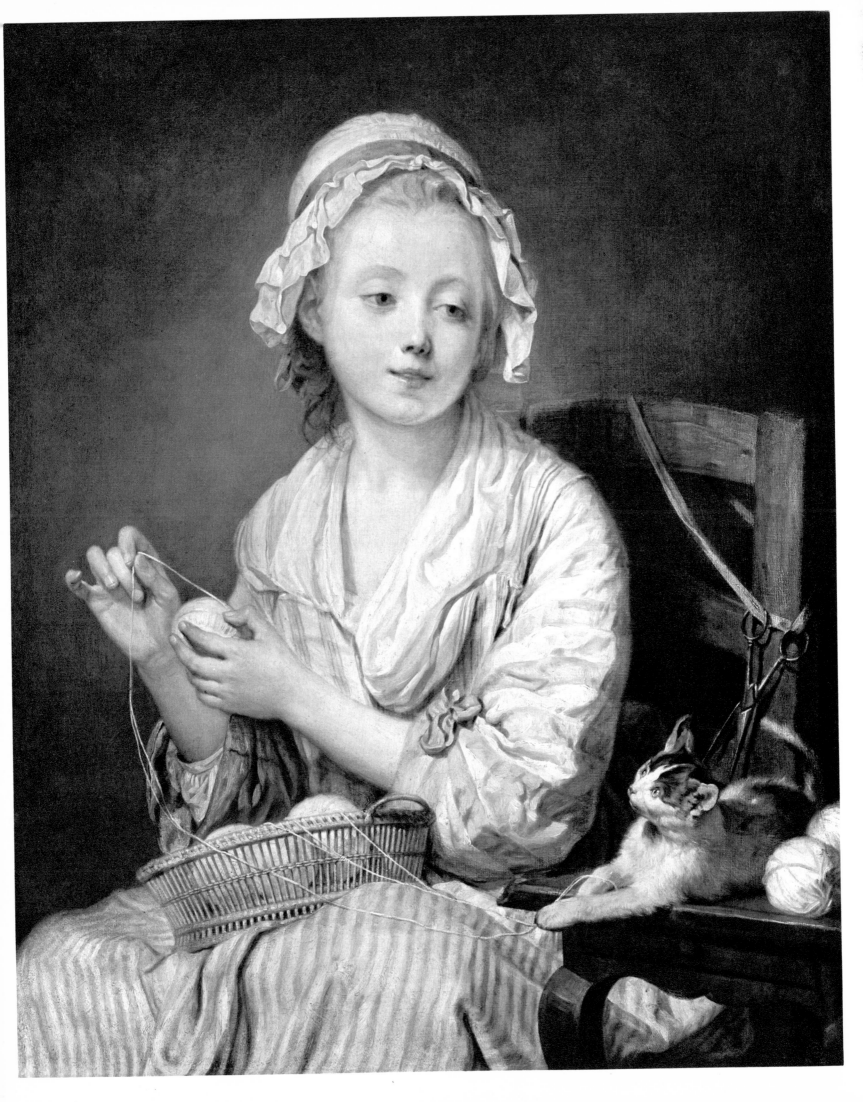

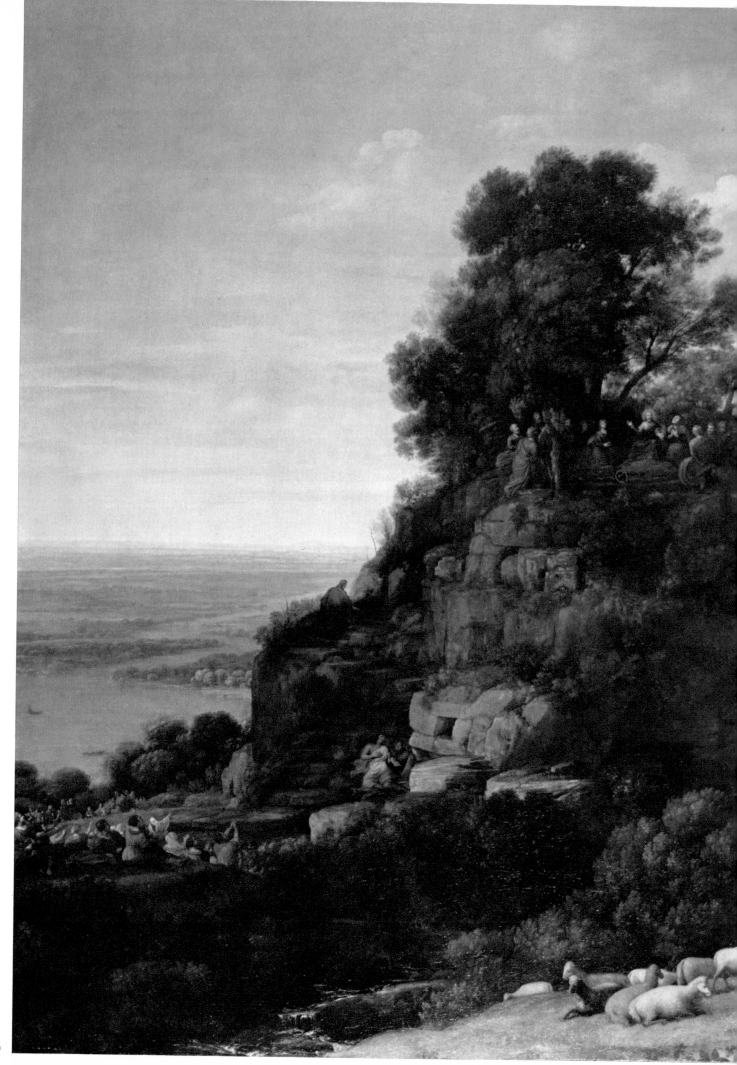

CLAUDE LORRAIN
(1600–1682)

THE SERMON ON
THE MOUNT
Oil, on canvas
67½ × 102¼ in.
(171.4 × 259.7 cm.)

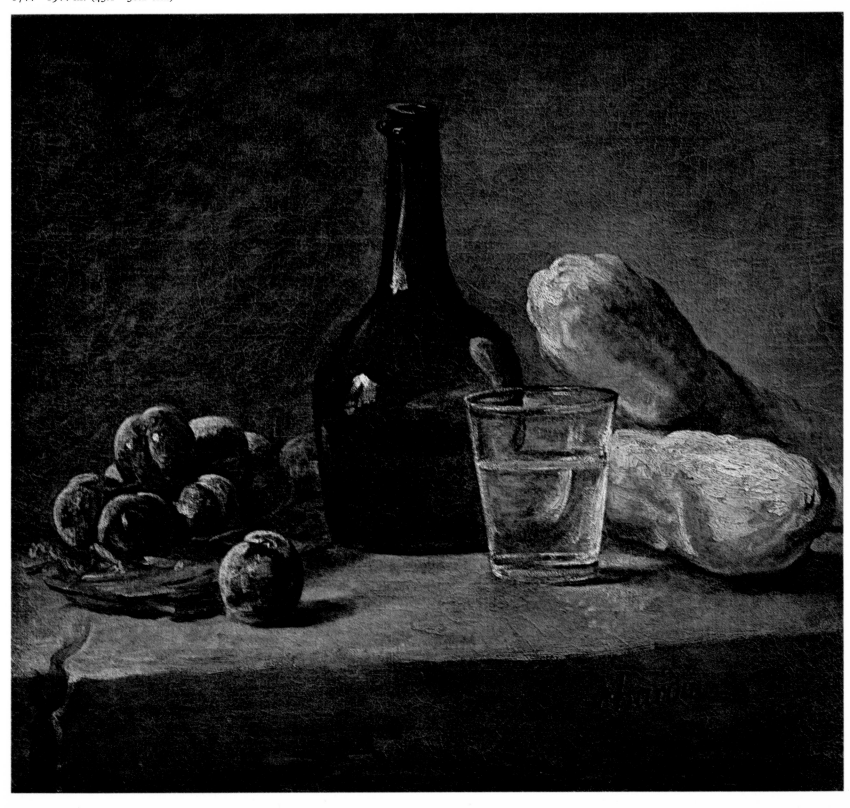

◁ Jean-Baptiste Greuze (1725–1805)

THE WOOL-WINDER

Oil, on canvas

29⅜ × 24⅛ in. (74.6 × 61.3 cm.)

Jean-Baptiste-Siméon Chardin

(1699–1779)

STILL LIFE WITH PLUMS

Oil, on canvas

17¾ × 19¾ in. (45.1 × 50.2 cm.)

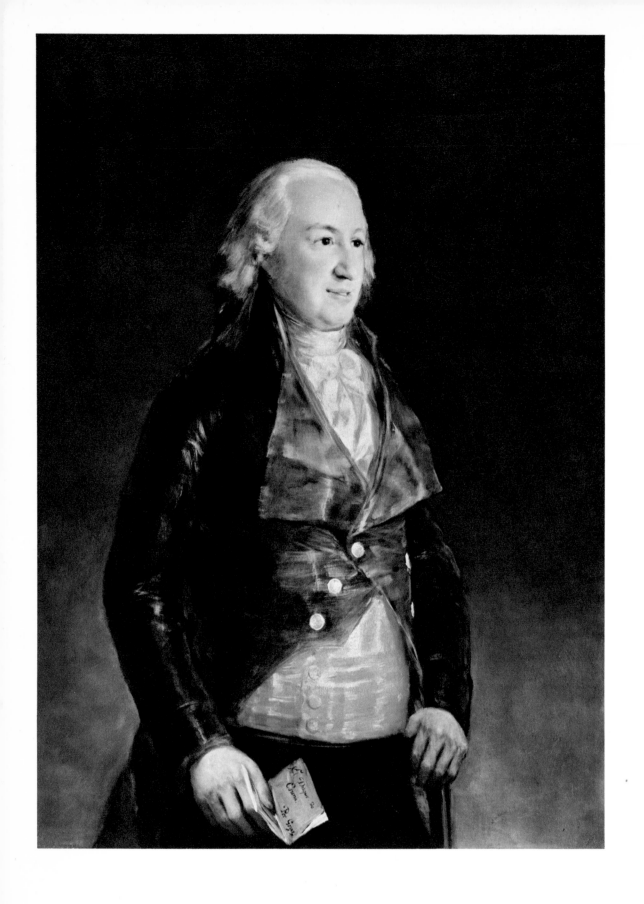

Francisco de Goya y Lucientes
(1746–1828)
DON PEDRO, DUQUE DE OSUNA
Oil, on canvas
44½ × 32¾ in. (113 × 83.2 cm.)

Jacques-Louis David (1748–1825)
COMTESSE DARU
Oil, on canvas
32⅛ × 25⅝ in. (81.6 × 65.2 cm.)

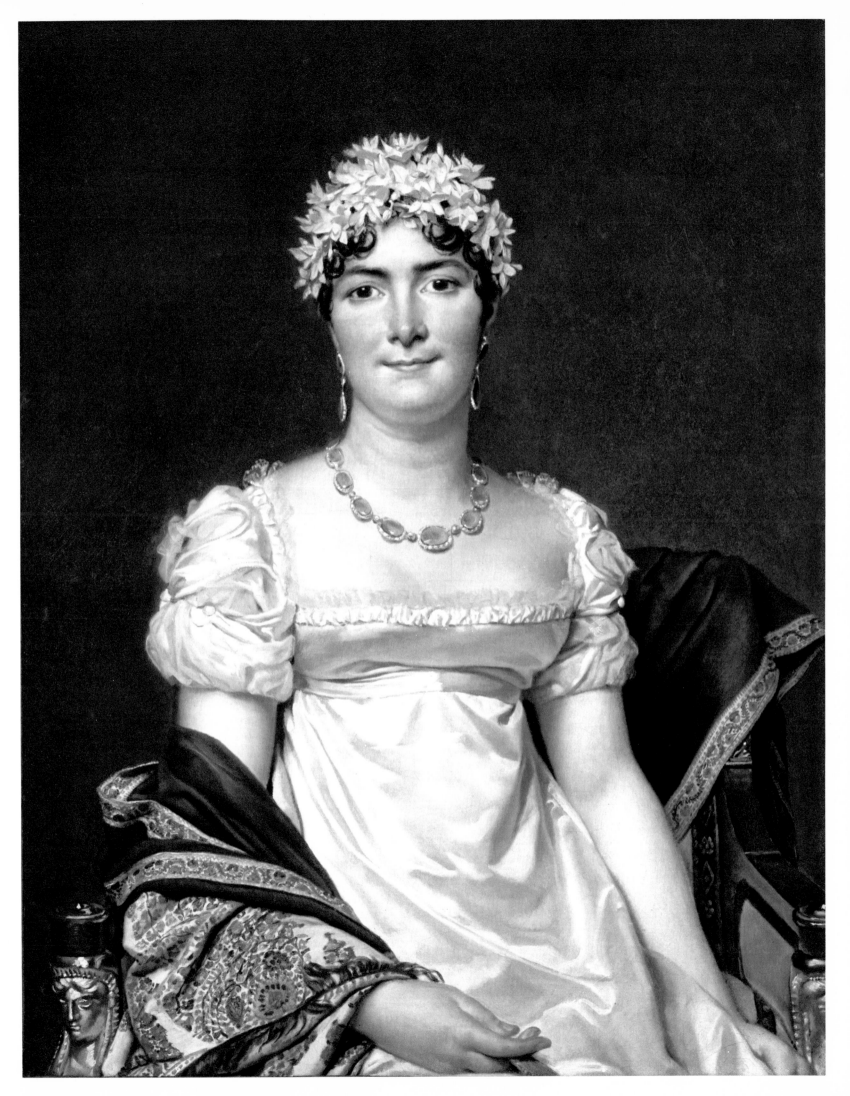

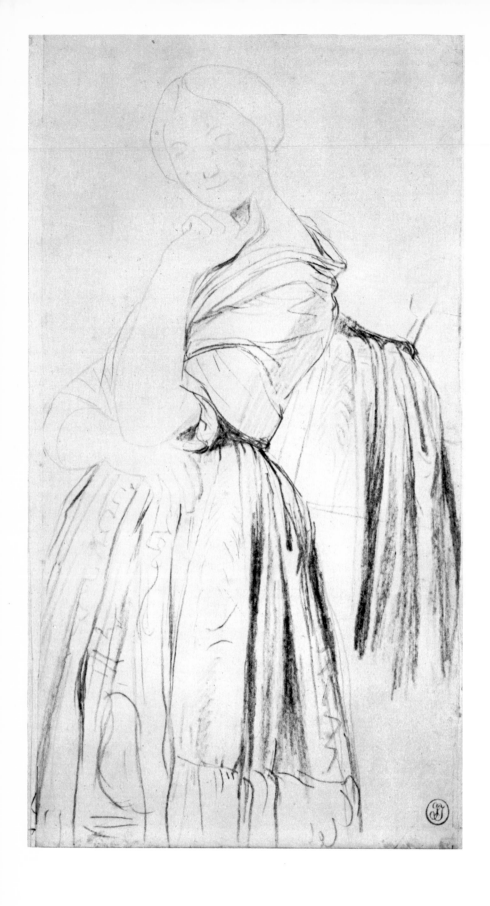

JEAN-AUGUSTE-DOMINIQUE INGRES
(1780–1867)
STUDY FOR THE PORTRAIT
OF THE COMTESSE D'HAUSSONVILLE
Black chalk over pencil, on white paper
14⁷/₁₆ × 7⁷/₁₆ in. (36.7 × 18.9 cm.)

JEAN-AUGUSTE-DOMINIQUE INGRES
COMTESSE D'HAUSSONVILLE
Oil, on canvas
51⅞ × 36¼ in. (131.8 × 92 cm.)

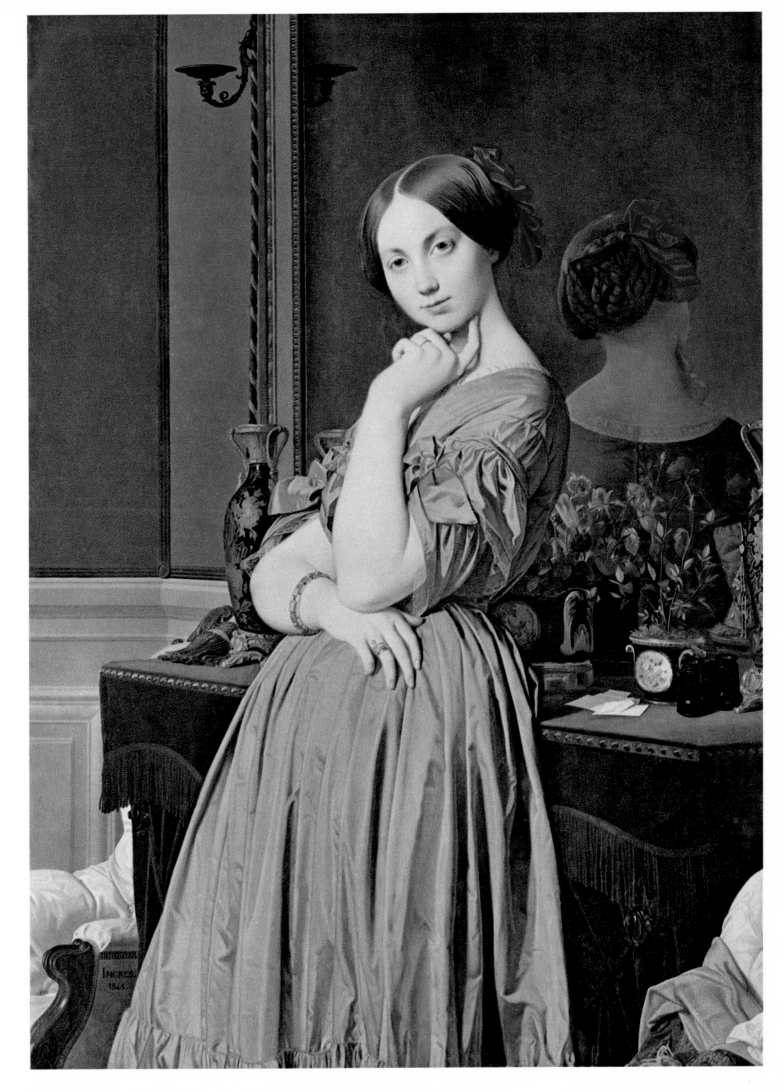

Mr. Frick bequeathed to the Collection only a half dozen paintings by American artists: Gilbert Stuart's portrait of *George Washington* and five paintings by Whistler. *The Ocean* was painted in Valparaiso, Chile, in 1866 and is clearly influenced by Japanese color prints. Whistler designed its frame, as he did the costume worn by *Mrs. Frederick Leyland* in his portrait of her. Leyland, one of Whistler's chief patrons, commissioned from him the famous Peacock Room. The three other Whistler portraits in the Collection represent distinctly colorful personalities: *Rosa Corder*, a fellow artist; *Lady Meux*, who once rode to a hunt on an elephant; and *Robert, Comte de Montesquiou-Fezensac*, the poet and dandy.

JAMES ABBOTT McNEILL WHISTLER
(1834–1903)
THE OCEAN
Oil, on canvas
31¾ × 40⅛ in. (80.7 × 101.9 cm.)

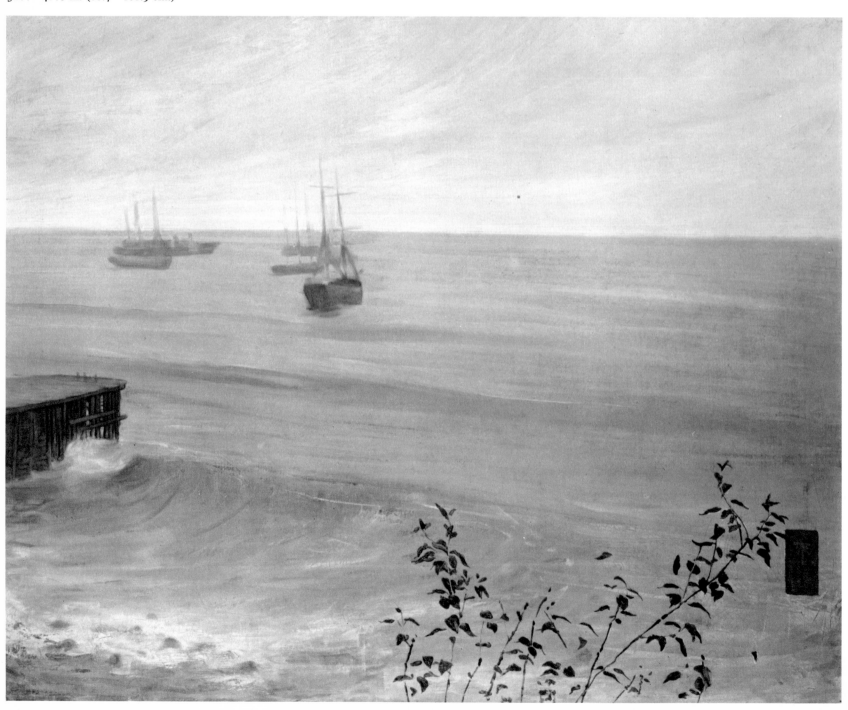

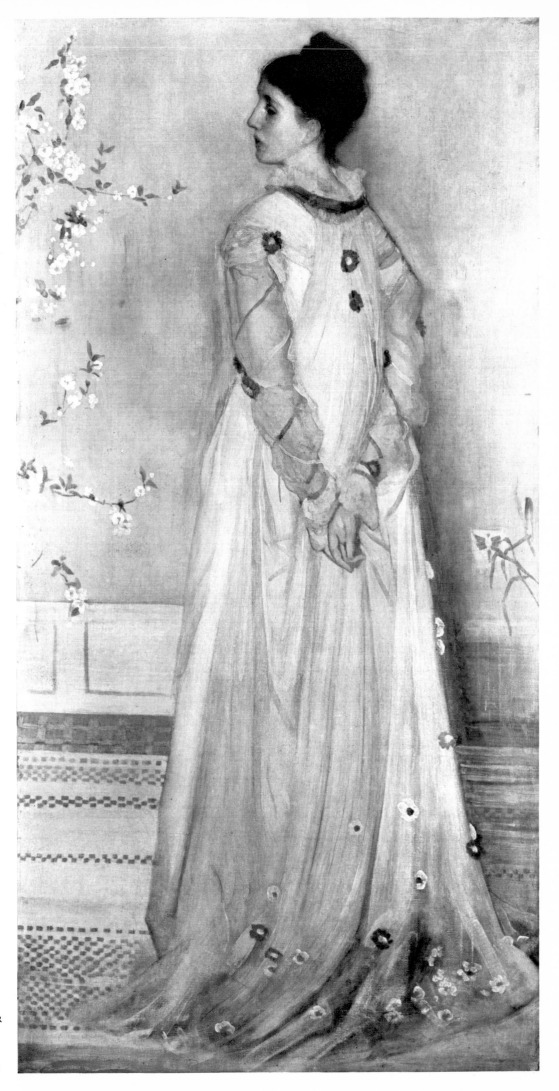

JAMES ABBOTT MCNEILL WHISTLER
MRS. FREDERICK R. LEYLAND
Oil, on canvas
77⅛ × 40¼ in. (195.9 × 102.2 cm.)

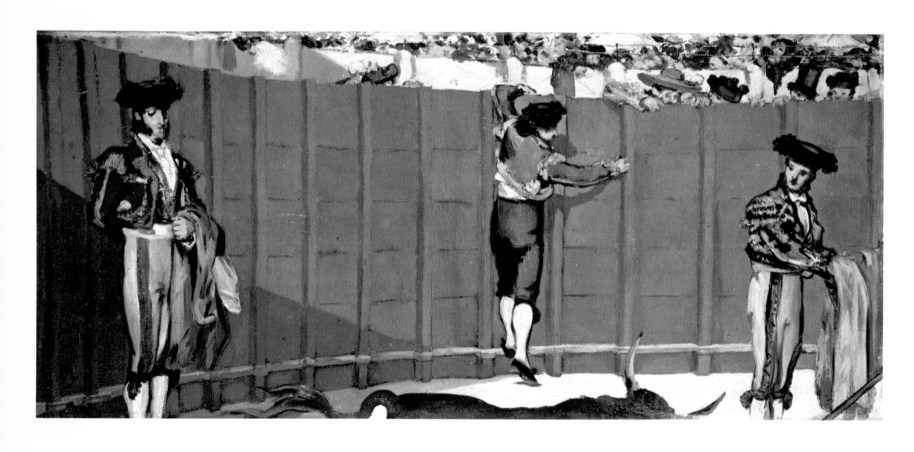

ÉDOUARD MANET (1832–1883)

THE BULLFIGHT

Oil, on canvas

18⅞ × 42⅞ in. (47.9 × 108.9 cm.)

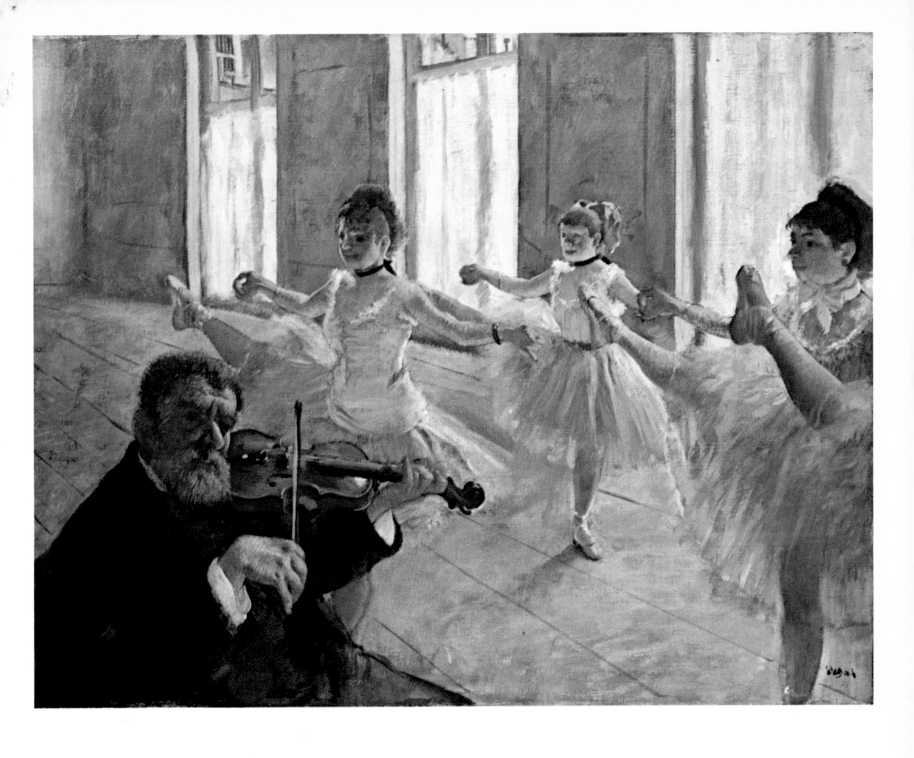

HILAIRE-GERMAIN-EDGAR DEGAS
(1834–1917)
THE REHEARSAL
Oil, on canvas
18¾ × 24 in. (47.6 × 60.9 cm.)

The Court

The Court, with its barrel-vaulted skylight, fountain, coupled columns, and colonnades, was designed by John Russell Pope to occupy the site of a former open carriage court. In the niches of the cornice, at the north and south ends of the court, have been placed two French eighteenth-century bronze busts of a *Boy* and a *Girl.* Around the court stand five portrait busts. Those on the west side are of a *Jurist,* by Danese Cattaneo, and of *Antonio Galli,* by Federico Brandani. On the east side are two celebrated warriors: the *Duke of Alba,* by Jacques Jonghelinck, and the *Maréchal de Turenne,* possibly by Antoine Coysevox. Houdon's subtly detailed marble bust of the *Marquis de Miromesnil,* Keeper of the Seals under Louis XVI, completes this series of portraits.

Adjacent to the pool is the bronze *Angel* by Jean Barbet. Though the origins and purpose of this major piece of French late Gothic sculpture are mysterious, the date is most precise: an inscription on the left wing states that it was cast on March 28, 1475.

The tropical plants and flowering shrubs about the pool are changed frequently throughout the year, providing a place of quiet beauty in the heart of a busy city.

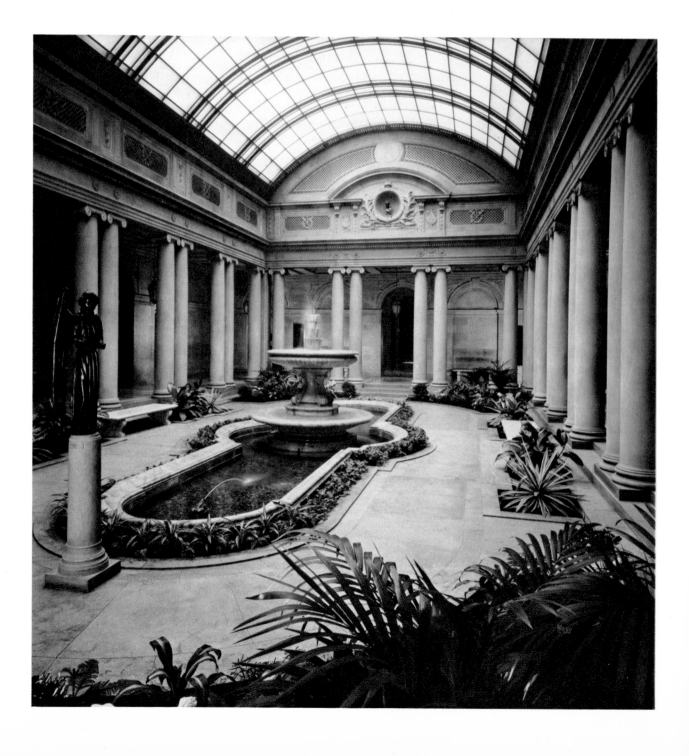

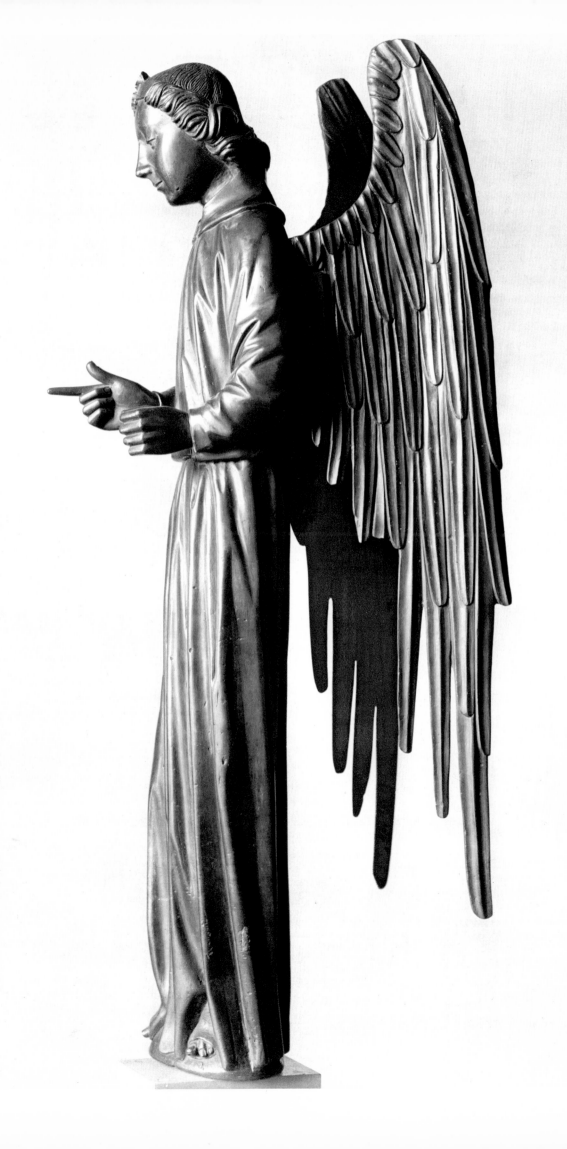

JEAN BARBET (active 1475–d. 1514)

ANGEL

Bronze
Height: 46 11/16 in. (118.6 cm.);
Height of figure: 45 11/16 in. (116.1 cm.)

Index of Illustrations of Works of Art

(Items marked with asterisks appear prominently in general room views)